PEEBLES
THROUGH TIME
Liz Hanson

AMBERLEY PUBLISHING

Acknowledgements

There are many people to whom I am grateful for kindly giving their time and expertise during the compilation of this book.

I would particularly like to thank Donald Swanson and Stuart Acres for sharing their exhaustive local knowledge, Douglas Whitie for his photographs, Chris Atkinson for sharing his collection of West Linton postcards, and Keith Miller for those of Innerleithen. A special thanks to Duncan Davidson for his family photographs of upper Tweed. Thank you too to Mollie McIntosh for allowing me to reproduce the lithograph of Walkerburn, and to Kieran Whyte for that of Darnhall.

Others that have generously helped in many and diverse ways are Gary Scott, Alex Kirika, Dorino Margiotta, The Keg, Donald Culbertson, Bel Kay, David Baird, the Tontine Hotel, Robert Barr, Leonard Grandison, Catherine Barr, George Futers, Cathy Ratan, Ted McKie, Nick and Lillian Slater, Fi Martynoga, Kay Pringle, Joyce Clarke, Davie Clarkson, Jackie Sommerville, Mary Brownlie, Deborah Stewartby, Tom Shearer, Sandy Howitt, Janet Hunter, Audrey Mackenzie, Maureen Thornborrow, Robert Little, Stuart and Mary Reid, Peebles Old Parish Church (especially Alistair MacFarlane) and the staff at Tweeddale Museum.

I dedicate this book to my dear friend Jacqui

First published 2011

Amberley Publishing
Cirencester Road, Chalford
Gloucestershire GL6 8PE

www.amberley-books.com

Copyright © Liz Hanson 2011

The right of Liz Hanson to be identified as the Author of this work has been asserted in accordance with the Copyrights, Designs and Patents Act 1988.

ISBN 978-1-4456-0075-8

British Library Cataloguing in Publication Data.
A catalogue record for this book is available from the British Library.

Typeset in 9.5pt on 12pt Celeste.
Typesetting by Amberley Publishing.
Printed in the UK.

Introduction

'The town of Peebles looks very pretty from the Neidpath road; it is an old town built of grey stone.'—Dorothy Wordsworth, 1803

These words were written when Peebles was a secluded, pastoral community that had altered little for hundreds of years. The main industry was farming, so the population remained fairly static. All this changed with the arrival of the railway in 1855, the first textile mill in 1858, and tourism soon after. All hastened the town's growth and development, although only the last of these endured and still contributes significantly to the local economy. This is hardly surprising for such a bonny place.

Peeblesshire is a county of rounded hills and steep-sided valleys, in which discrete villages are peppered, and nourished by 40 miles of the River Tweed (hence the old name of Tweeddale). Peebles lies at its heart, with Innerleithen 6 miles downstream, but otherwise the county is sparsely populated. However, the area enjoys easy road access to Edinburgh, which allows many residents to commute to work in the city.

Burgh records were not started until 1456, but sufficient references exist to be able to visualise the Peebles of the late twelfth century. Two large edifices existed at that time – Peebles Castle and St Andrew's Church. The simple castle sat atop the rocky knoll on which Peebles Parish Church now stands, commanding views up and down the River Tweed and northwards through the valley of Eddleston Water. It was used as a residence for royal visitors, who were possibly there to hunt. Half a mile away, on the elevated ground behind Hay Lodge Park, was St Andrew's Church; tradition has it that an ecclesiastical centre connected to St Mungo, the patron saint of Glasgow, existed here from the sixth century. There would have been a track between here and the castle, running down Old Town and along Biggiesknowe. A few dwellings would be scattered in the vicinity and the river would have been crossed by fords. The church was a substantial building, but it was eventually burnt down by the English in 1548, although the tower is still intact, having been restored by William Chambers in the nineteenth century.

In 1261, the discovery of a buried cross and stone urn, full of human bones and ash, precipitated the decision by Alexander III to erect the Cross Kirk on the site. Then, in 1367, David II conferred on Peebles the status of Royal Burgh, an indication of its importance.

Up until the sixteenth century the town had enjoyed relative peace, but then times became more turbulent. Defence against English invasion caused a town wall to be erected in 1570, enclosing the area east of the castle, and for added protection, three-storey bastel houses were put up. Part of the wall and a corner tower can still be seen in the corner of Edinburgh Road car park and the names of Eastgate, Northgate and Bridgegate refer to this fortification.

In 1645, plague reached Peebles. The terror of this fatal illness was compounded by the arrival of the Marquis of Montrose, who had been defeated at Selkirk by a Covenanting army. Five years later, Cromwell unsuccessfully attacked Neidpath Castle, which still stands proud today. The Jacobite Rebellion did not greatly affect Peebles, although a camp of the Pretender's army was pitched in Arnotshaugh (Hay Lodge Park) *en route* to England.

Having survived the darker eras, including the Great Plague, Peebles went on to flourish during the Industrial Revolution, embracing the only major industry to visit the town, that of woollen and textile manufacturing. The ensuing prosperity moulded Peebles into the place it is today, a town that enjoys a high quality of life.

Bibliography

Atkinson, T. C., *Old West Linton* (Stenlake Publishing, 2002).

Brown, J. L., and I. C. Lawson, *History of Peebles* 1850–1990 (Mainstream Publishing, 1990).

Caplan, Neil, *Border Country Branchline Album* (Ian Allan, 1985).

Cruft, Kitty, John Dunbar and Richard Fawcett, *Pevsner Architectural Guides: Buildings of Scotland – Borders* (Yale University Press, 2006).

Fox, Andrew, *A Living Village* (1987).

Grant, Will, *Tweeddale* (Oliver & Boyd, 1948).

Lorimer, Andrew, *Life and Times in the Upper Tweed Valley*, ed. Margaret Railton (Tuckwell Press, 2001).

Ordnance Gazetteer of Scotland (1896).

Pearce, F. W., *Walkerburn: Its Origins and Progress* 1854–1987.

Rae, Gilbert, *Historic Haunts of Peeblesshire* (Oliver & Boyd, 1948).

Scott, Sheila (ed.), *Glimpses of Old Broughton* (Biggar Museum Trust, 1985).

Strang, Charles Alexander, *Borders and Berwick* (The Rutland Press, 1994).

Wilson, Rhona, *Old Peebles* (Stenlake Publishing, 1998).

Young, Alex F., *Old Innerleithen, Walkerburn and Traquair* (Stenlake Publishing, 2004).

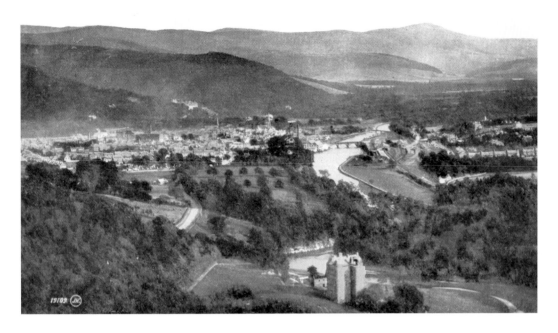

Peebles from the West

The attractive situation of Peebles is apparent from this western elevation above Neidpath Castle. Built on the haughland of the River Tweed and its tributary, Eddleston Water, the town nestles in a bowl of Borders hills. The nearest river crossing is Tweed Bridge, which carries road traffic; the distant one for the railway was removed when the line closed and the pedestrian Priorsford Bridge was erected close by. This wide 1920s panorama is now obscured by the mature forestry of Jedderfield Plantation.

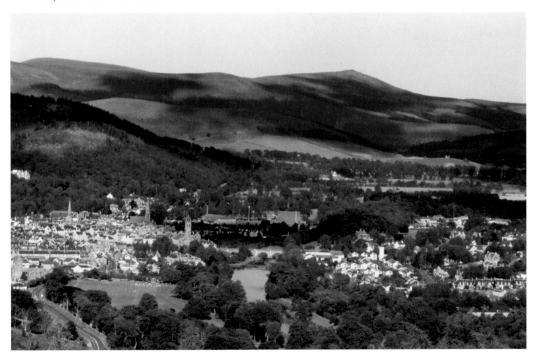

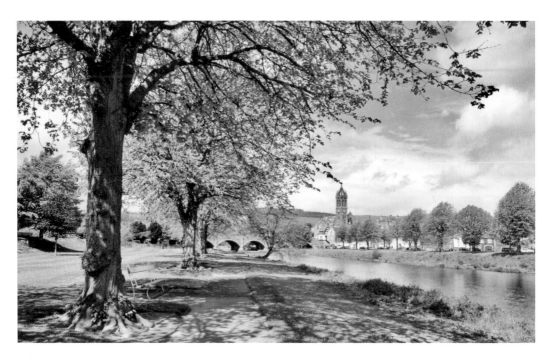

The River Tweed, Peebles
The lush, grassy banks below Tweed Bridge were once used for grazing animals, particularly sheep, but they have gradually evolved into a popular amenity area. Riverside walks are favoured by both visitors and local people and this view of Peebles defines the town in the eyes and memories of many.

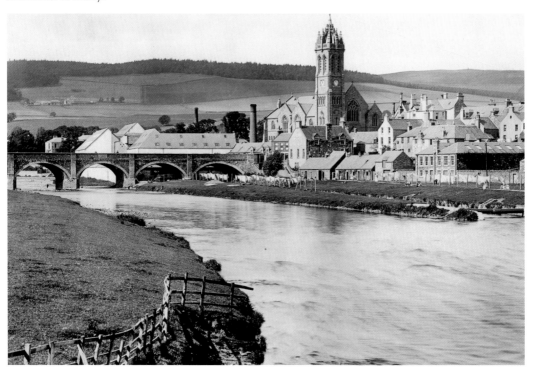

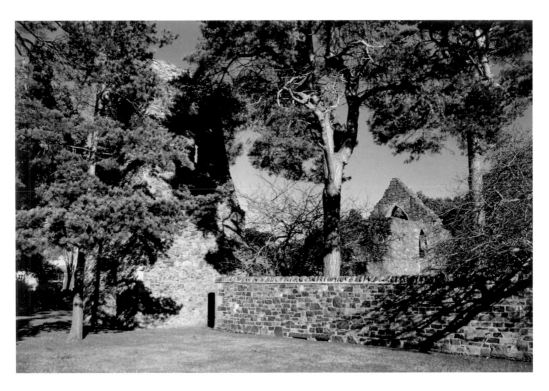

The Cross Kirk

This ecclesiastical structure was built due to the discovery of a buried cross in 1261, during the reign of Alexander III. A small community of Red Friars resided here and established a convent on the northern side around 1473, at which time the tower porch was added. After the Reformation (and until a new one was built in 1784), it was used as the parish church – the original one, St Andrew's, was burnt down by the English in 1548.

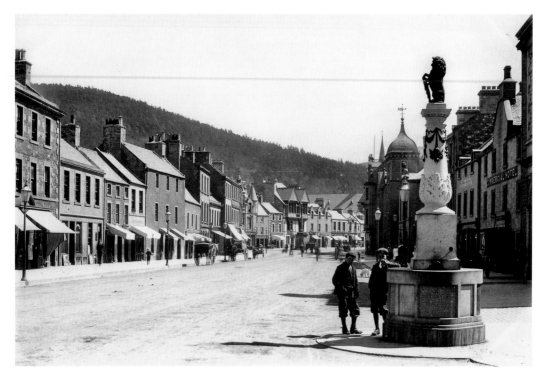

High Street from the Veitch Memorial

Erected in the High Street in 1898, the granite drinking fountain was dedicated to an eminent Peeblean, Professor Veitch, who taught logic and metaphysics at the University of Glasgow and was also a prolific poet. He was born in Biggiesknowe, Peebles, in 1829 and had a deep love for the natural world, particularly the hilly countryside surrounding his home town, which was a source of inspiration for his writings.

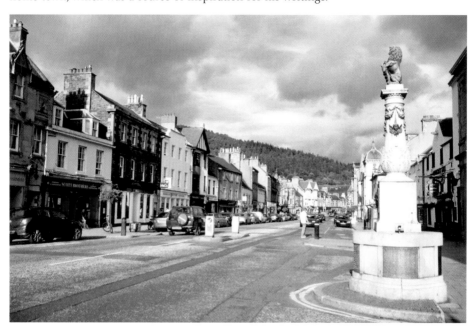

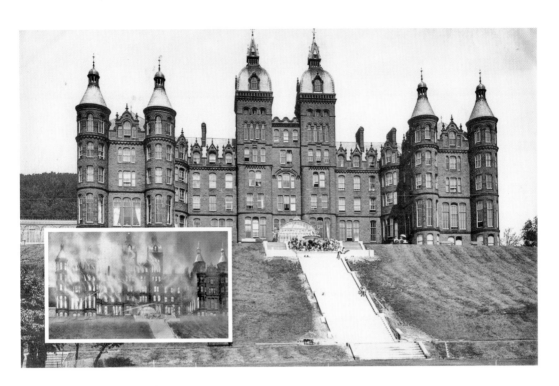

Peebles Hydro Hotel

This is a very striking landmark on Venlaw Hill; the views from this site across to Hundleshope Heights and Glensax are stunning. The original hydro was built of red Dumfriesshire stone in the French renaissance style in 1878–80 – a time when railways and the reputation of hydropathic benefits brought many visitors to Peebles. A catastrophic fire razed it to the ground in 1905, but rebuilding was completed two years later. During the Second World War, it was used as a naval hospital.

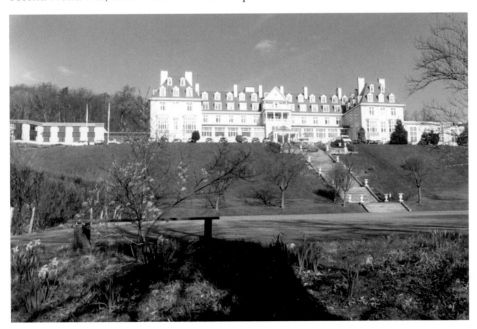

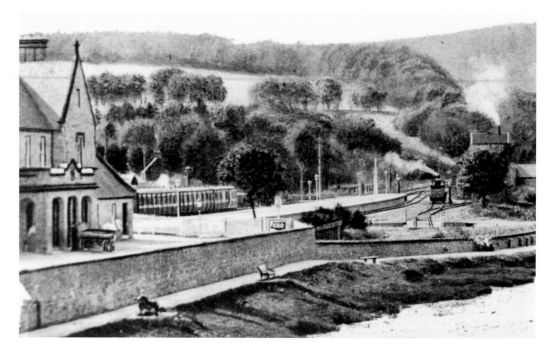

Caledonian Station

The branch line from Symington Junction, connecting Peebles to Glasgow in the west, was opened in 1864 by the Caledonian Railway, nine years after the rival company – North British – had started its service from Edinburgh. Caledonian station was south of the river, while the main station was on the north side, so a short line across an iron bridge was required to link them. Tweed Bridge Court (amenity housing) now occupies the Caledonian station site.

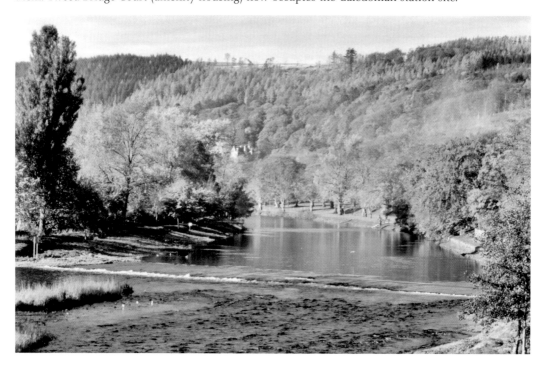

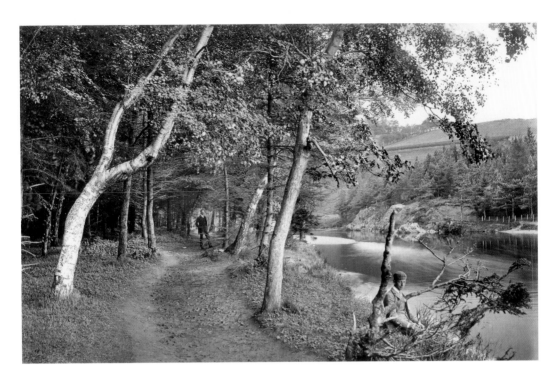

Neidpath Gorge

As the River Tweed flows downstream to Peebles, it is channelled through the steep gorge of Neidpath, creating some deep pools, before widening out as it enters the meadowland of Hay Lodge Park. One of these pools was used by the local swimming club for diving and is known locally as the Dookits. Remnants of the metal diving board can still be seen, but it was mostly removed in the 1950s.

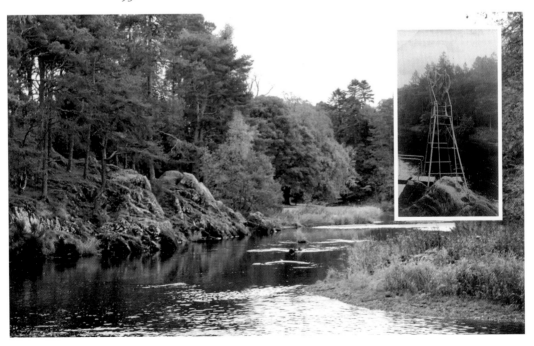

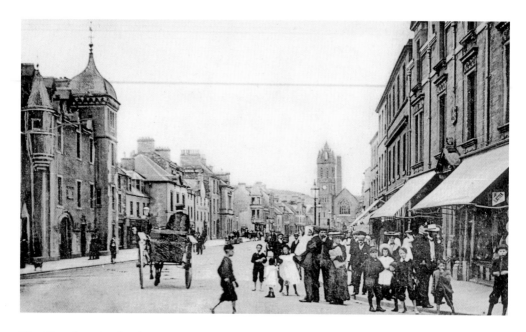

The Chambers Institution

The prominent Baronial-style Chambers Institution in the High Street was variously owned by the Cross Kirk, Hays of Yester and the Duke of Queensberry. In 1857 it was acquired by the publisher and writer Dr William Chambers, who gifted it to the town 'for purposes of social improvement'. After alterations, it was opened as a library, museum and gallery in 1859, and fulfils these same functions to this day.

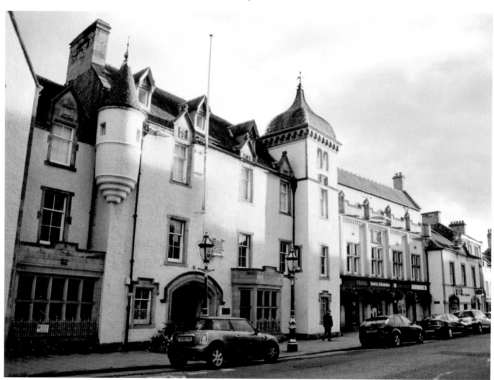

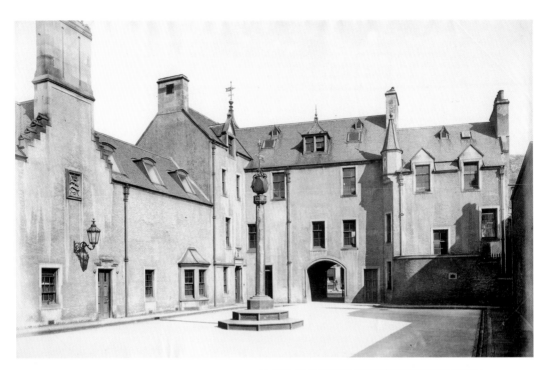

Quadrangle of the Chambers Institution

The ancient shaft of the Mercat Cross, which had stood at the intersection of Northgate, Eastgate and High Street, became unsafe by the end of the eighteenth century, and in 1807 it was removed by Sir John Hay of Kingsmeadows for restoration. He erected it in the quadrangle of the Chambers Institution temporarily, until it was reinstated in the High Street in 1895. The war memorial was built in the courtyard in 1922.

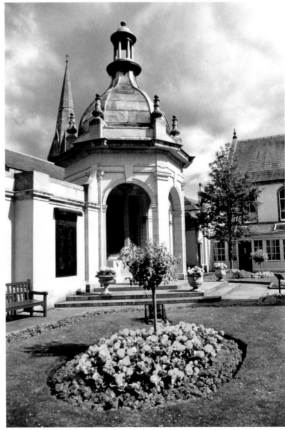

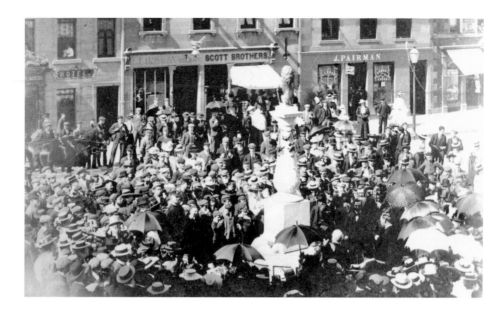

Scott Brothers

'We need to visualise the High Street of Peebles in 1867. Trading was carried out by 5 bakers, 6 grocers, 7 grocers and spirit dealers, 1 greengrocer, 4 butchers, 7 boot- and shoemakers, 4 linen and woollen merchants, 1 dressmaker and milliner, 6 tailors, 1 clock- and watchmaker, 2 stationers and booksellers, 1 cabinetmaker and upholsterer, 1 glass and china dealer, 3 saddlers, 1 druggist, 1 tobacconist and hairdresser, 2 nailmakers, 2 plumbers and gas fitters, 5 ironmongers, 2 builders and masons, 2 painters, 6 nursery and seedsmen, 1 printer and bookbinder, 1 weaver, 1 rope-maker, 1 cab and carriage owner and an auctioneer.' (From *History of Peebles 1850–1990* by J. L. Brown and I. C. Lawson.) Scott Brothers, ironmongers, is now the only shop in the High Street still owned and run by the original family, having first been in the smaller premises next door to the present one. Castle Warehouse in Old Town has been trading since 1896.

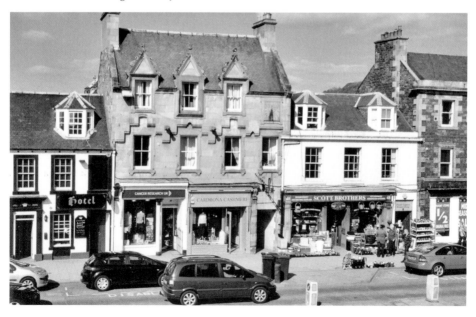

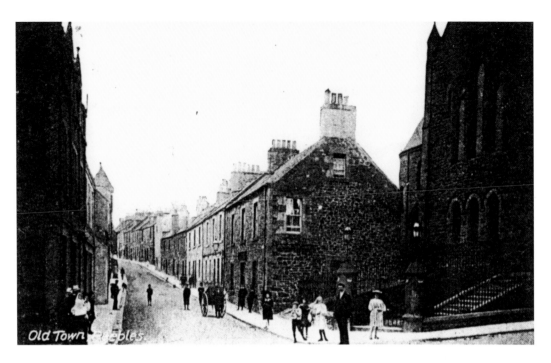

Old Town

Nowadays, Old Town is approached from Cuddy Bridge, which crosses Eddleston Water just before its confluence with the River Tweed. However, prior to the first one being built in 1815, it was reached from Biggiesknowe, a centre of handloom weaving in the eighteenth century. Many of the Old Town cottages, some of which would have been thatched, have since been demolished.

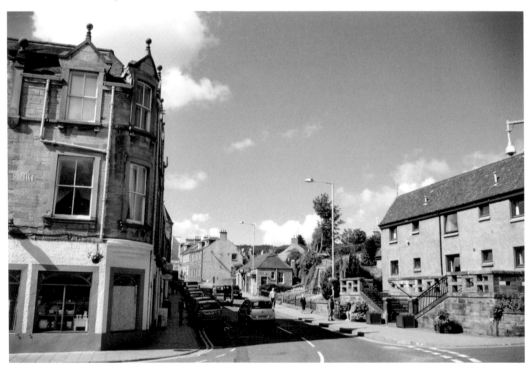

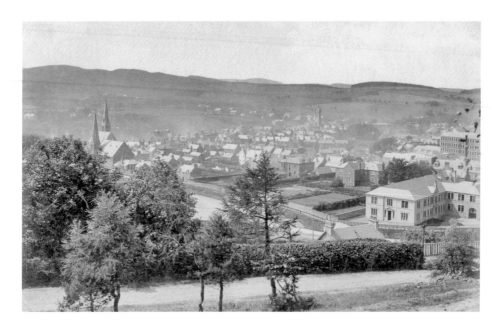

Peebles from Venlaw Hill

In the mid-1800s, Dean Park was the site of the livestock market (centre right in the photograph above), which was relocated to accommodate a railway station when the North British Locomotive Company opened the line from Edinburgh in 1855. The new form of transport had an enormous impact on the town, improving distribution of woollen goods and bringing large numbers of visitors from Edinburgh. It was, in fact, the catalyst for tourism in Peebles, which remains a significant part of the town's economy.

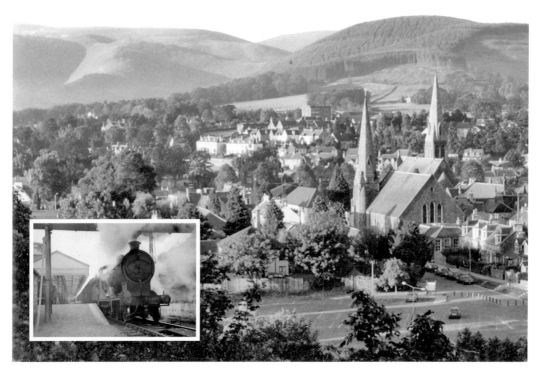

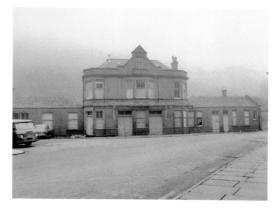

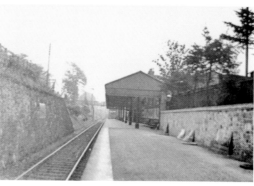

The Demolition of North British Station

This station developed a reputation for being neat, clean, colourful, and adorned with plants and flowers. The main road north to Edinburgh was built on the track of the railway, which closed in 1962. The line was a victim of the 'Beeching cuts' and a special 'Farewell to Peebles' train ran from Edinburgh on the day of closure. It must have been a sorry sight to witness the demolition of the buildings; the only one left is the goods office. The utilitarian locality is now shared by Sainsbury's and a car park.

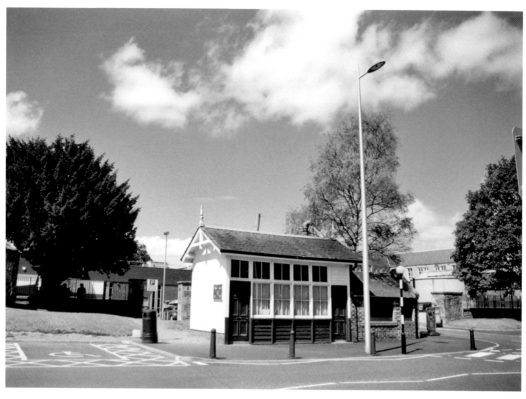

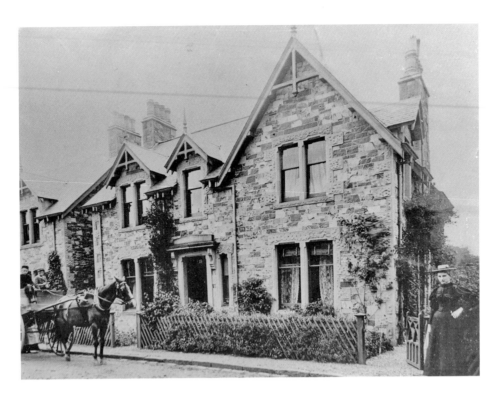

Gladstone Place

It is likely that this street was named after William Ewart Gladstone, the Liberal prime minister at the time of building. These houses were part of the expansion of Peebles during the woollen mill boom of the mid-1800s. Horse-drawn milk carts were still being used as late as the 1930s. Veitch's clothing business was started in a house in Gladstone Place, before moving to Veitch's Corner House in the High Street a year later in 1885. Regrettably, the shop recently closed.

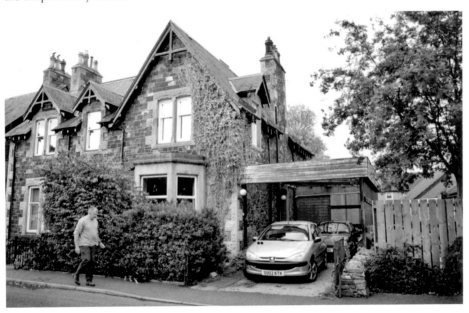

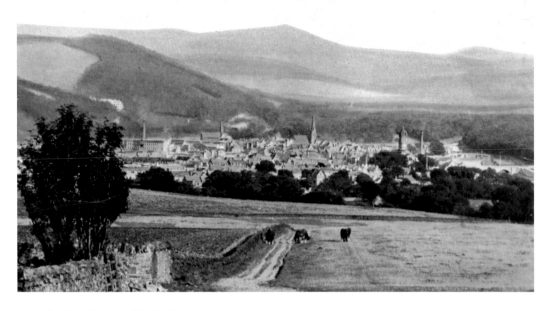

Peebles from Jedderfield

Prior to the creation of a road through Neidpath Gorge, a drove road led from Peebles to the west over Jedderfield. In 1918, the Earl of Wemyss sold this land to Peeblesshire District Council and a proposal was put forward to make an eighteen-hole golf course there, the original nine-hole one being on the other side of the river at Morninghill. This municipal course commands splendid views across the valley.

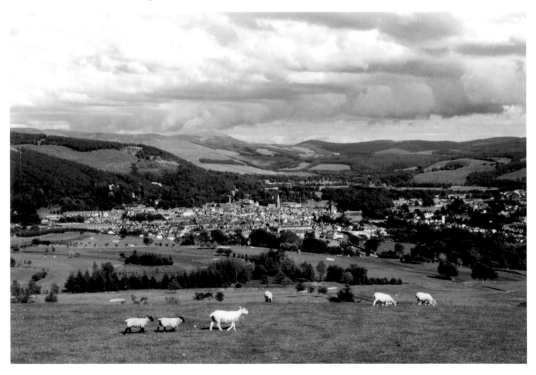

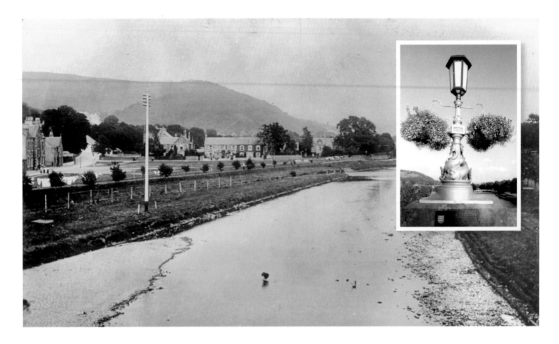

Tweed Green from Tweed Bridge

Sand and gravel banks, with their shallow pools, are not conducive to navigation, but are attractive to salmon. Three of these fish are portrayed by the town crest of Peebles; symbolically, one travels upstream and two return. *Contra nando incrementum* means 'against the stream they multiply'. The ornamental fish lights on Tweed Bridge are used by starlings as nesting holes.

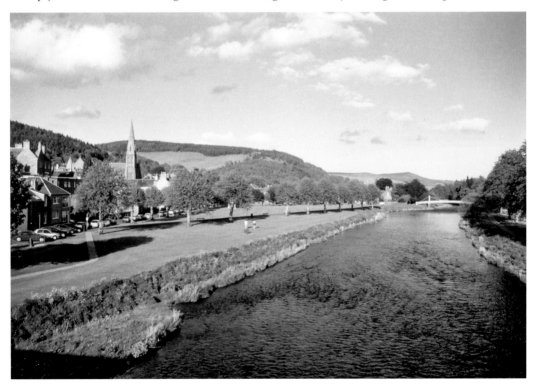

Hay Lodge Park

The meadowland on the northern side of the Tweed was originally known as Arnotshaugh, and was owned by the Chapel of St Mary near Peebles Castle at the foot of what is now the High Street. The Jacobean army set up a camp there in 1745. Ownership eventually fell to Alexander Campbell, who built a high wall around the area, which is known to this day as Campbell's Dyke.

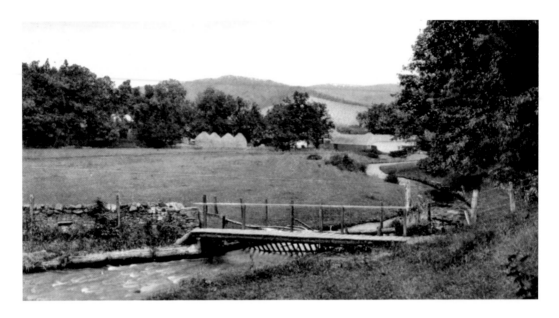

Gypsy Glen

The reason for the 'romantic' name of this glen is vague, although the sheltered copse with clean, fresh water from Glensax Burn about one mile from town could easily have found favour with the travellers. Certainly this was a drove road from Peebles to Yarrow, which would have been used by travellers *en route* from the Highlands to England. The wide, walled track across the hills is still visible.

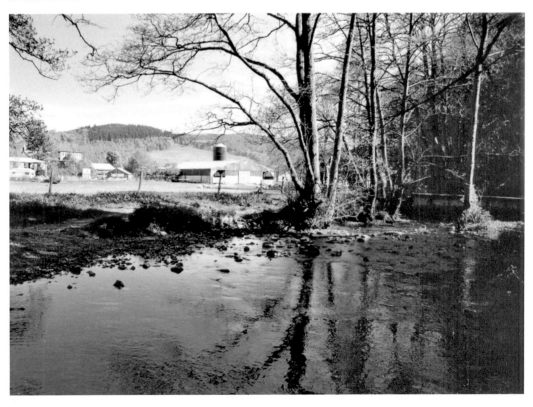

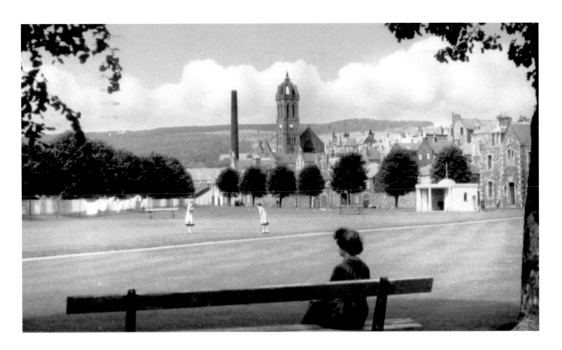

Tweed Green

This was once the common land of Peebles. In the 1950s, the building on the right was a school and the lower ones further along were stables. The washing lines show it was also used as a drying green. In the 1880s, the local newspaper started a fund for 'Improvements of Peebles', one task of which was to make Tweed Green more aesthetically pleasing. The area became known for leisure pursuits such as quoits and pitch-and-put. Nowadays, it is a pleasant, verdant parkland between the High Street and the river.

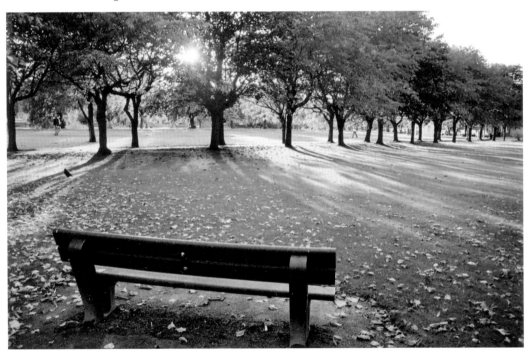

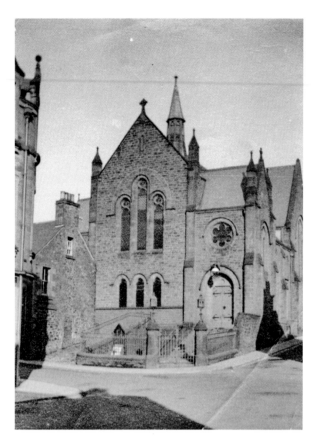

St Andrew's Church

Built in 1847 of red sandstone, this United Presbyterian church must have been an imposing landmark, standing as it did at the foot of two slopes of Elcho Street Brae and Old Town. In 1977, the congregation merged with that of the Leckie Memorial Church in Eastgate (thereafter known as St Andrew's Leckie Parish Church). A sheltered housing complex (St Andrews Court) now occupies the site.

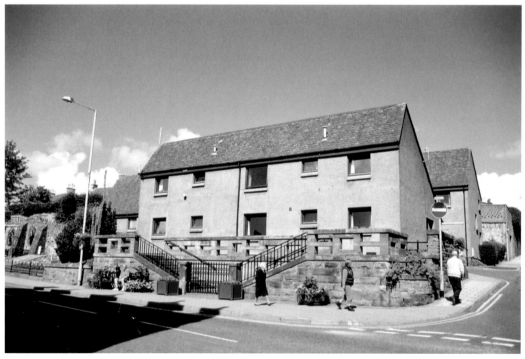

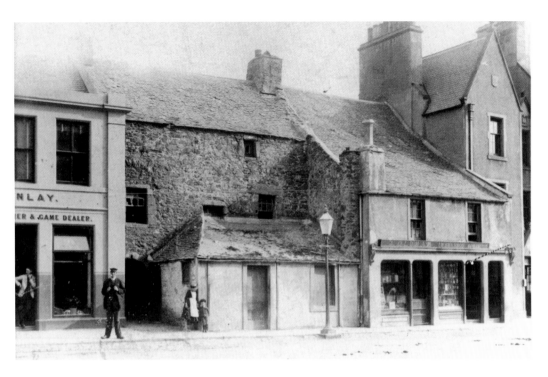

Mungo Park and Clement Gunn

Dr Mungo Park (1771–1805), whose humble surgery (the single-storey building above) was on High Street, was an adventurer who led two expeditions to Niger, the second of which was fatal to him. Dr Clement Gunn (1860–1935) on the other hand, dedicated his life and work to Peebles. As well as a doctor, he was a church elder, an author and founder of the post of 'Warden of Neidpath'. He built his house and surgery at the top of the Old Town and named it Lindores after the loch in Fife on which he met his wife while ice-skating. The turreted building, in which Dr Gunn lived and practised, is now a bed and breakfast.

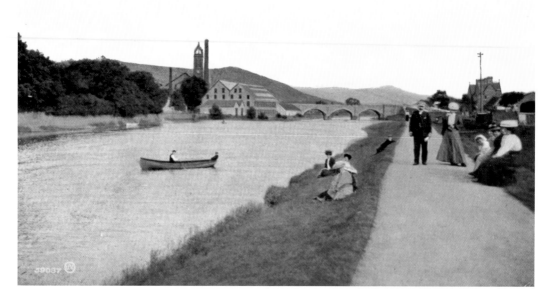

Tweedside

Caledonian station, the terminus for trains from the west, is silhouetted on the right near Tweed Bridge, while the main Peebles station, on the North British line, was a mile away across the river. The rival companies did not co-operate to make travelling easy. Apparently, Edinburgh trains were scheduled to arrive 10 minutes after the departure of the service to Glasgow.

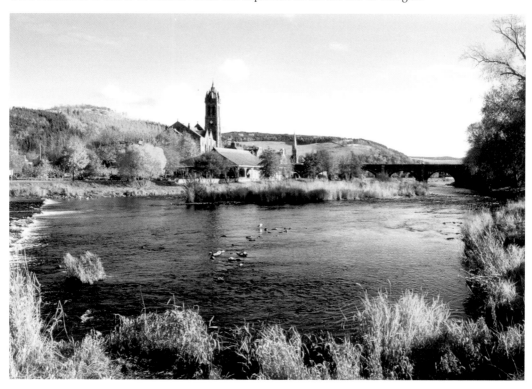

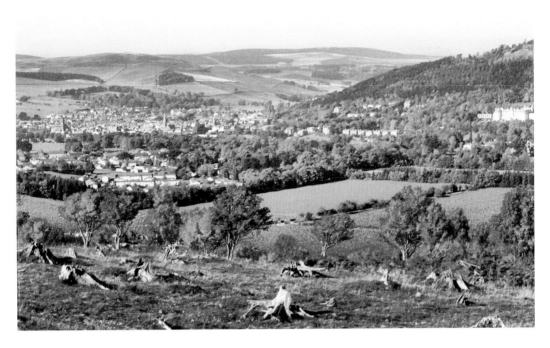

Peebles from Gypsy Glen

The land in the middle distance is part of Whitehaugh Farm, and began to be developed for housing in the 1960s. Expansion along the south-eastern edge of Peebles continues; contrast the 1990 view (top) with that of 2010, below.

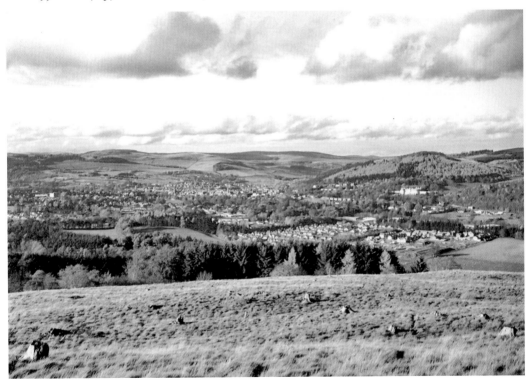

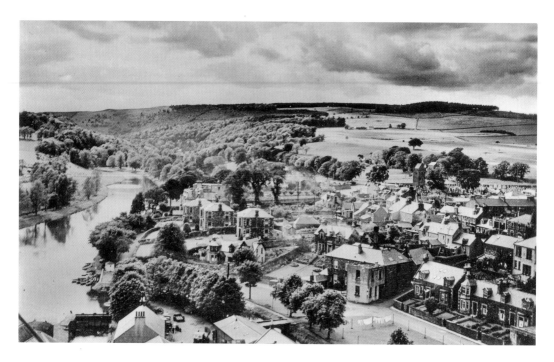

Peebles from the Parish Church Tower

The elevated vantage point from the tower of Peebles Parish Church only serves to emphasise the beautiful setting of the burgh, with magnificent panoramas in every direction. Fotheringham Footbridge was opened in 1953, linking the walks on both sides of the Tweed. The 'eyesore' – centre right in the old image – was the partly demolished laundry, which was pulled down in the 1970s.

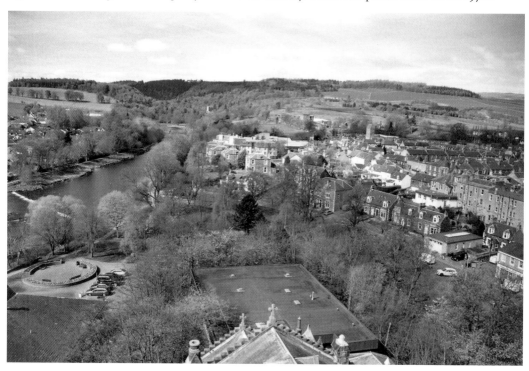

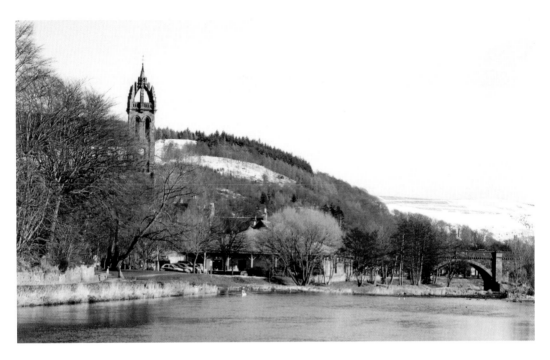

Thorburn's Mill

The ground between the parish church and the river was occupied by a corn mill, which, in 1856, was replaced by Tweedside Woollen Mill, which utilised water power to drive the machinery. After mixed fortunes, Walter Thorburn & Bros took over the business in 1865, but fire destroyed the premises in 1965. A swimming pool built here opened in 1984.

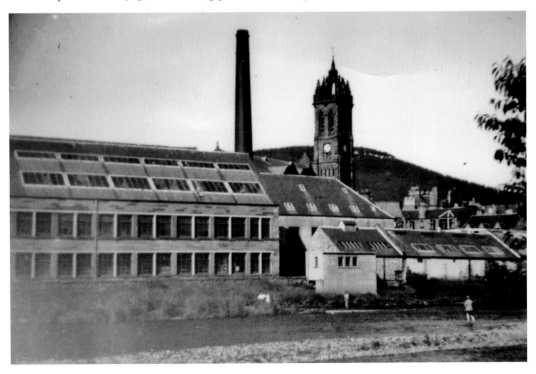

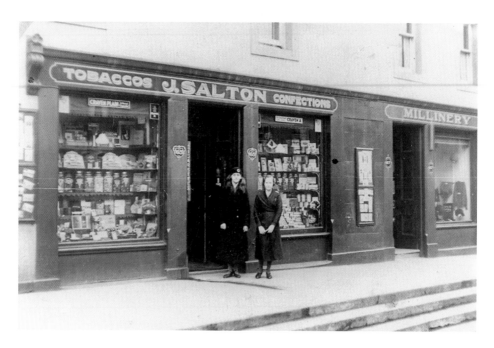

The Tatler

The lower floor of this building dates back to 1639, and behind it lies the cobbled yard of Parliament Square, along one side of which is a door lintel engraved 'RSHM 1743' (it is a marriage stone). The Tatler has been run by an Italian family, Margiotta, for over thirty years. Two brothers left Italy in 1975 to look for work and opened cafés in both Edinburgh and Peebles. They served delicious coffee long before the rise of today's ubiquitous beverage bars.

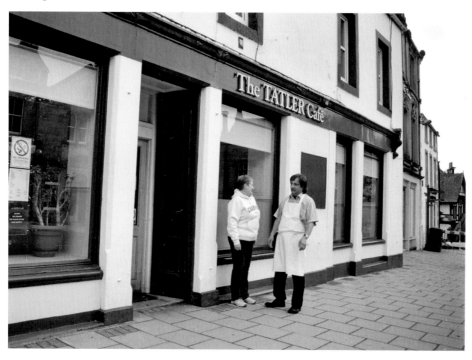

Veitch's Corner

Northgate was, for centuries, the route north out of Peebles. Above the doorway of the Cross Keys Inn, which sits on this thoroughfare, is written 'The Original Cleikum Inn 1653'. At the junction with High Street is the distinctive 1885 building, known as Veitch's Corner, from which the Veitch family ran a high-quality clothing and haberdashery business for four generations. It closed its doors for the last time in 2007, having traded for 123 years. It is sad to see the windows of this characterful shop plastered with an array of advertising posters.

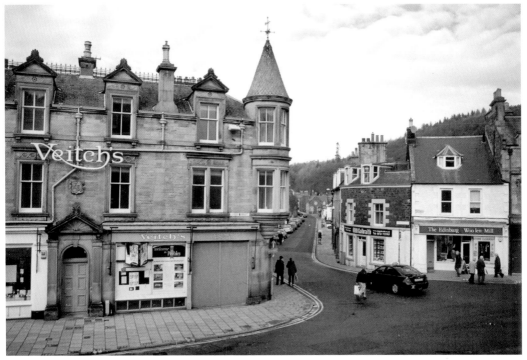

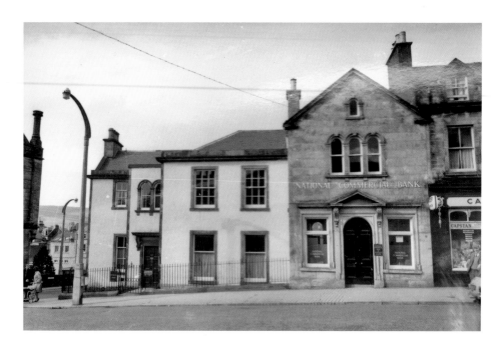

Bank House

It is hard to visualise this location as it was in the seventeenth century, when it was the site of Chapel of the Virgin and enclosed within the grounds of Peebles Castle. In 1860, as the textile trade increased, the Union Bank (later renamed Commercial Bank) opened a branch here. Bank House, next door, was occupied by Walter Buchan (the uncle of John Buchan), who was town clerk for forty-two years. Controversy abounded when, in 1984, plans were submitted to widen Cuddy Bridge, thereby demolishing Bank House. So great was the outcry from Peebleans that the main body of the house was saved, and in fact the issue was the catalyst for the creation of Peebles Civic Society.

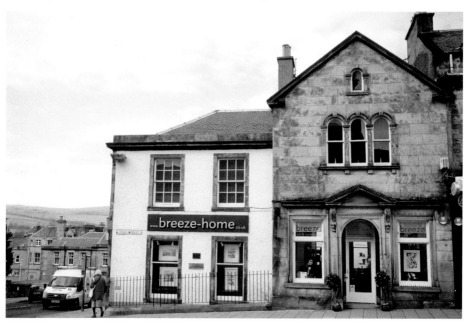

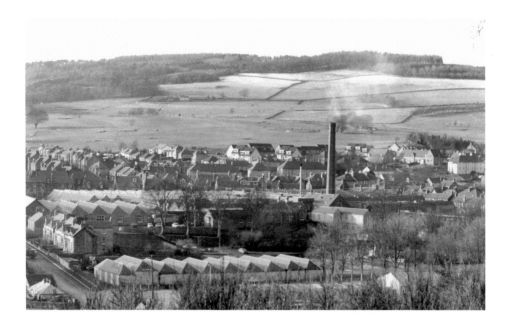

Ballantyne's Mill
The townscape of Peebles was for about a hundred years peppered with mill chimneys, reflecting the basis of the town's economy. Gradually, evidence of the mill culture has disappeared and the last chimney came down in 1980 at Robert Noble's March Street Mills, although this company still produces fine-quality fabrics. The factory was originally built by David Ballantyne to expand his Galashiels operation.

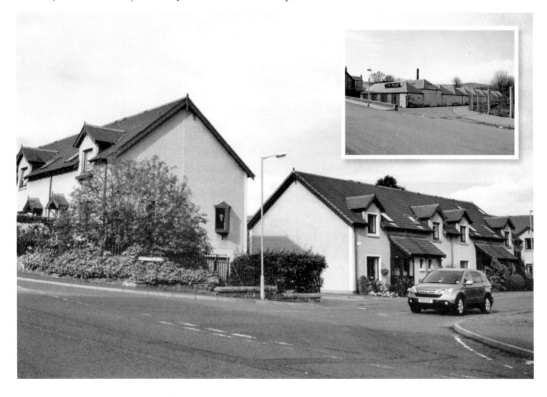

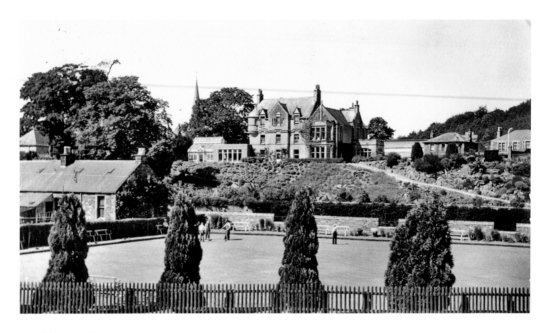

Peebles Bowling Green

Bowling has been a popular sport locally for hundreds of years. Peebles Bowling Club started in 1829, at which time the green behind Castlehill was used. The club moved to Walkershaugh in 1874. The large house in the background, Minden House, was the home of Henry Ballantyne; in 1934 it was extensively rebuilt and converted into the Park Hotel.

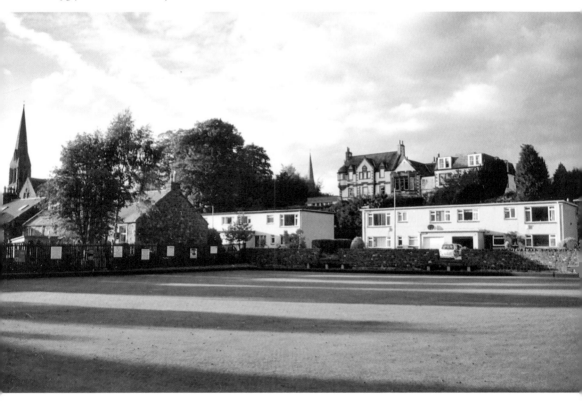

The Mercat Cross

The cross was first erected in Old Town in the fifteenth century; it sat on a plinth of four stones carved with the arms of the burgh and family crest of Frasers. It now resides in the Eastgate, where there are three churches. The spire on the left was the Free Church, which was converted to Eastgate Theatre and Arts Centre in 2004. The pinnacle buttresses on the right are part of St Peter's Episcopalian Church, while the stone pillars next door mark the entrance to Andrew Leckie Memorial Church, whose imposing profile is best seen from Tweed Green.

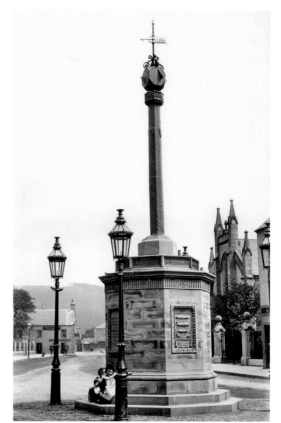

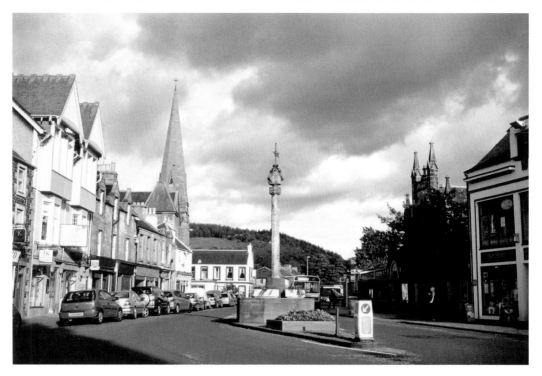

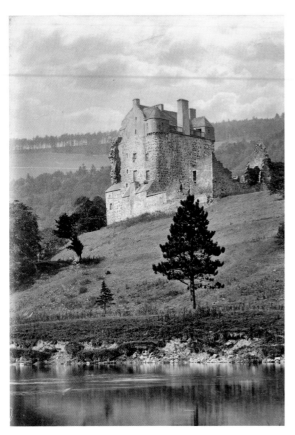

Neidpath Castle

The entrance to the steep, rocky Neidpath Gorge was an obvious defensive position for a castle. Built around 1300 as an L-plan tower with 11-foot-thick walls, it was remodelled in the seventeenth century after Cromwell's troops damaged it. The hanging gardens and yew tree avenue were planted at that time, but in 1795 the 4th Duke of Queensberry ravaged the grounds and cut down the trees – an act criticised in a poem by William Wordsworth.

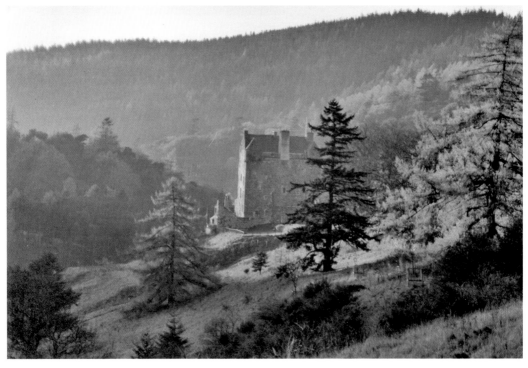

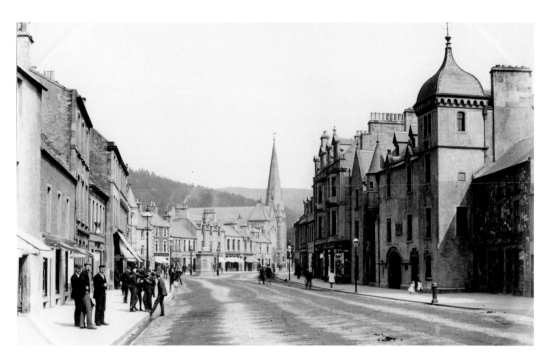

High Street, Looking East

In 1846, improvements began to the sixteenth-century High Street; the level was reduced by 2–3 feet, drains were installed, and protrusions, such as outside stairs, were removed. At that time, pedestrians only needed to watch out for fast-trotting horses – a sharp contrast with today's constant flow of vehicular traffic. Despite this, it remains an attractive and charming street.

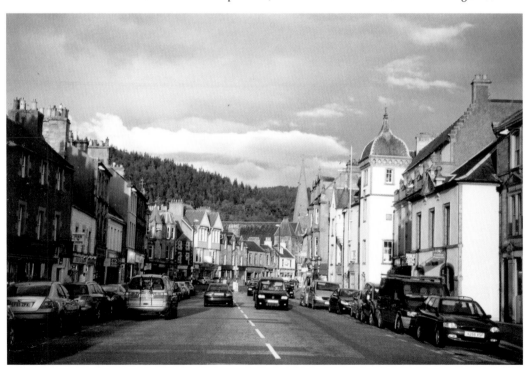

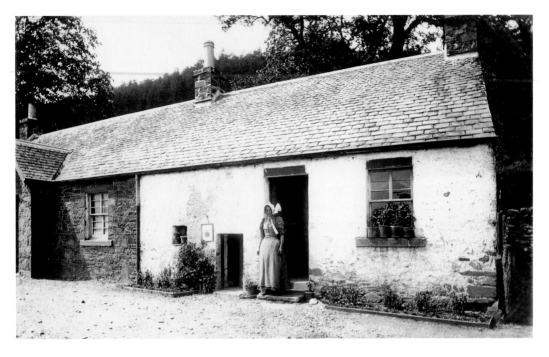

The Black Dwarf's Cottage

Born in 1741 at Easter Happrew, David Ritchie became known as the Black Dwarf. He had a deformity that Dr Mungo Park described as 'corkscrew stumps', and he also had extraordinary physical strength. He went to Edinburgh to make brushes, but was ostracised and returned to Manor Valley, where he built himself a low-roofed cottage at Woodhouse Farm. He used the small door on the left of the main entrance.

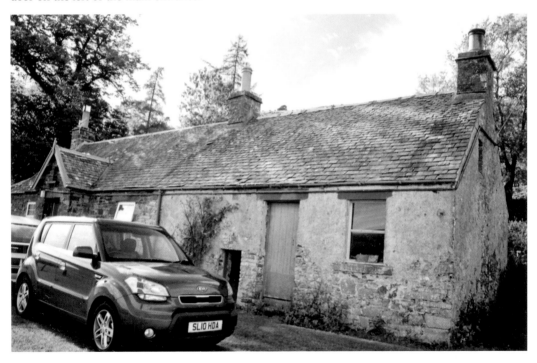

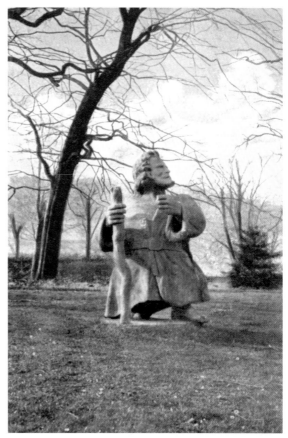

The Black Dwarf's Monument

Walter Scott met David Ritchie and such was the impression made that he wrote a novel named *The Black Dwarf.* His physique, strength and dislike of women (although he adored animals) were thought to be evidence of association with the devil. In order to ward off the evil spirits, a rowan tree was planted on his grave. A decade ago, the tree died and the Borders Council replaced it, but it too died. According to a local farmer, the old one came alive again and, at the time of writing, is full of leaf. The 1836 statue is in the grounds of nearby Hallyards House.

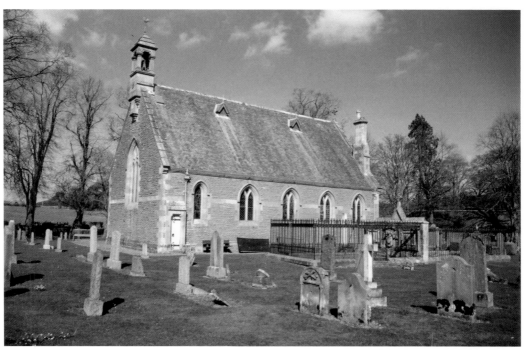

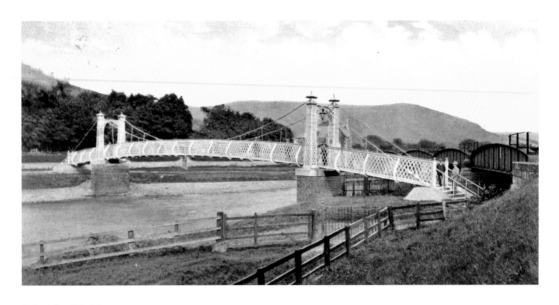

Priorsford Bridge

A footbridge has crossed the Tweed at this point since 1817 but the current structure dates from 1905. To celebrate the jubilee of Queen Victoria, Sir John Hay of Haystoun gifted land (Victoria Park) to the citizens of Peebles and the bridge afforded access to it from the town. The rail bridge, just visible, linked the Caledonian and North British stations and was dismantled in 1950.

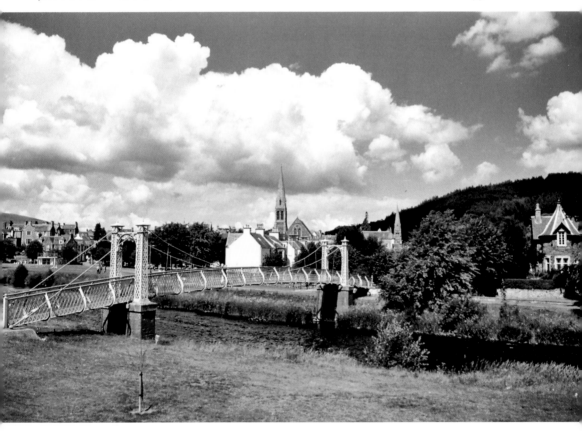

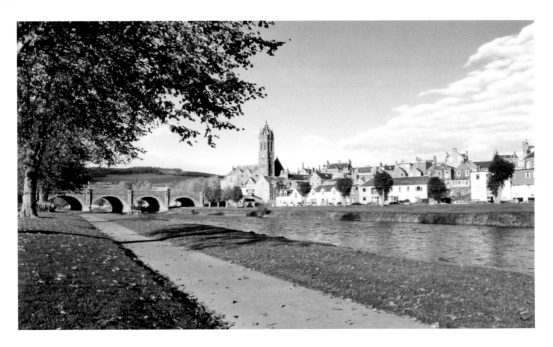

Tweed Bridge from the South

A river crossing here is thought to originate from the 1400s, but major improvements came in 1834, followed by the widening of the bridge in 1897, by which time pedestrians vied with horses and carriages for space. Currently, the pressure comes from increased population, and therefore road traffic; a proposal for a second road bridge is currently being considered.

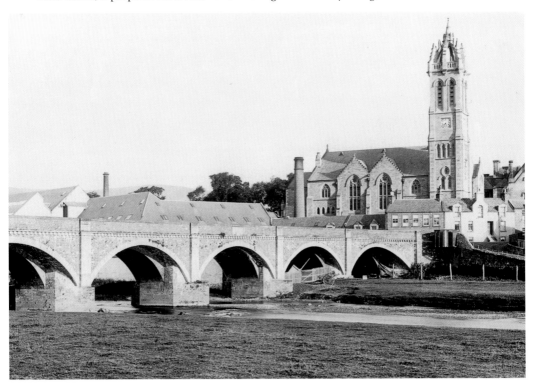

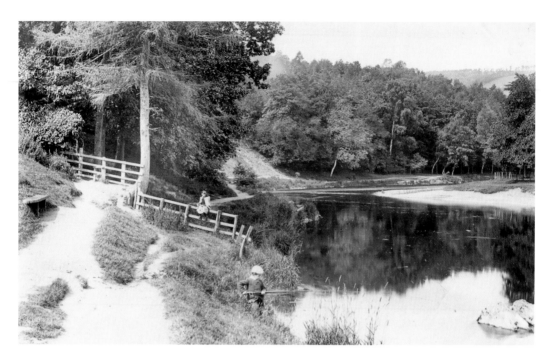

Quiet Pool

At the western end of Hay Lodge Park, approaching Neidpath Gorge, is a quiet stretch of the river, where, during the Riding of the Marches in the Beltane Festival, scores of horses ford the Tweed. The family firm of Grandison, famous worldwide for ornamental plasterwork, at one time dug sand and gravel from the river shore below Neidpath Castle, and ferried it downstream in the sand boat; it was last used in 1939, as became damaged during the Second World War.

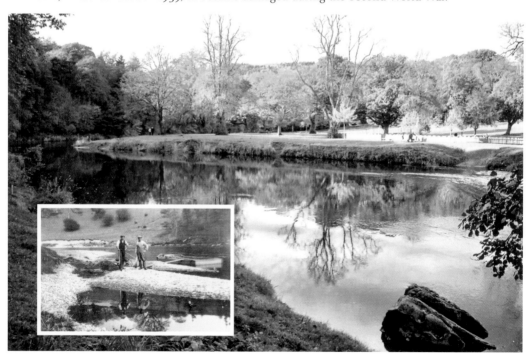

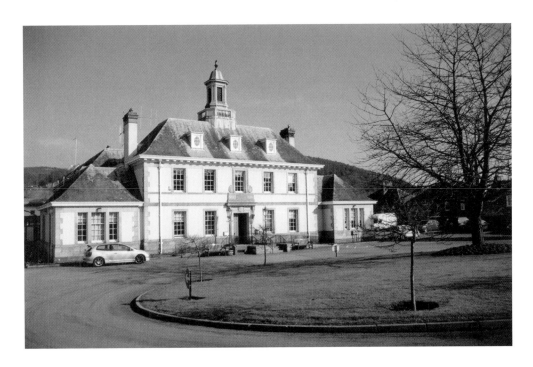

Rosetta Road

In 1807, Rosetta House was built by Thomas Young, a military surgeon, who took part in the Egyptian expedition to salvage the Rosetta Stone. A replica of the latter is integrated into the porchway of the house. Most of the residences in this long road were built in the early 1900s by the local authority to supply textile workers when the industry was booming. The union poorhouse was incorporated into the above building in 1934 for use as council offices.

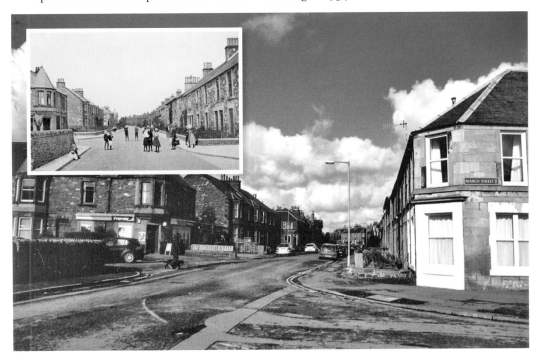

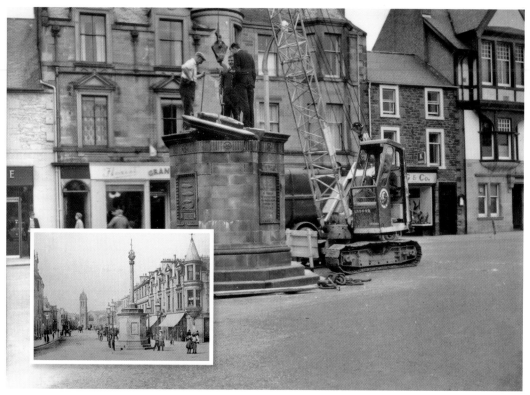

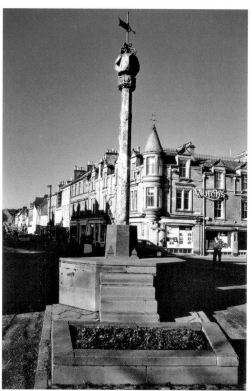

Relocating Mercat Cross

The inset photograph, taken in around 1900, shows the newly restored Mercat Cross on the high octagonal plinth at the junction of Eastgate, Northgate and High Street. By 1965, due to increased traffic, it was relocated to a safer place in Eastgate and placed on a new, lower plinth. The four original carved base stones now form part of a wall in a small public garden in the Northgate, the gap having been created by the demolition of cottages in 1930.

Upper Cuddyside

The road entering Peebles from the north runs parallel to Eddleston Water (The Cuddy). Full housing development along the banks has not been possible due to a swamp area below the Edinburgh Road, allowing a pleasant suburban pathway beside the water. On the other side there was, for years, a photographic processing laboratory run by Thomas Lister, whose excellence the author can verify. When the family retired fifteen years ago, apartments were put up on the site.

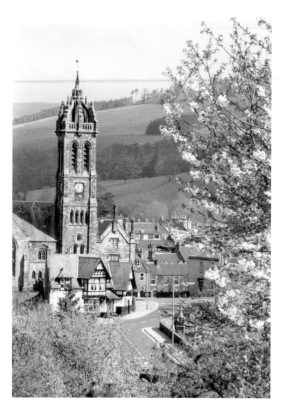

Tweed Bridge

In 1897, Tweed Bridge was widened for the second time. The old photograph illustrates the practicalities of traffic crossing the river prior to the improvements. The bearded man is John Laidlaw, great-grandfather of Leonard Grandison, whose family have specialised in ornamental plasterwork for four generations; it was the son of Mr Laidlaw who started the business in Peebles.

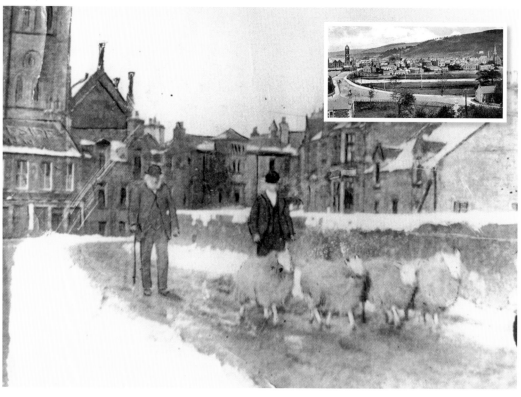

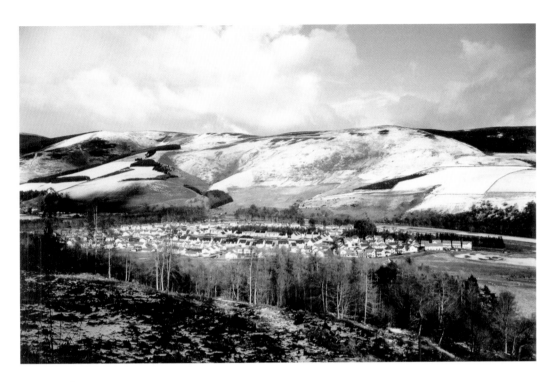

Cardrona

In the late 1980s, controversial plans were submitted to Borders Regional Council for the creation of a new village, hotel and golf course at Cardrona, half way between Peebles and Innerleithen. Eventually, and with certain conditions, the project was accepted and a substantial community has developed there. Cardrona House and the remains of the peel tower overlook the complex.

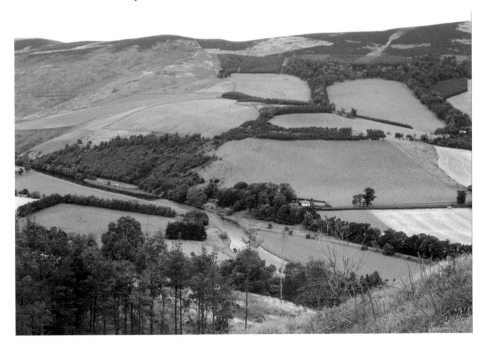

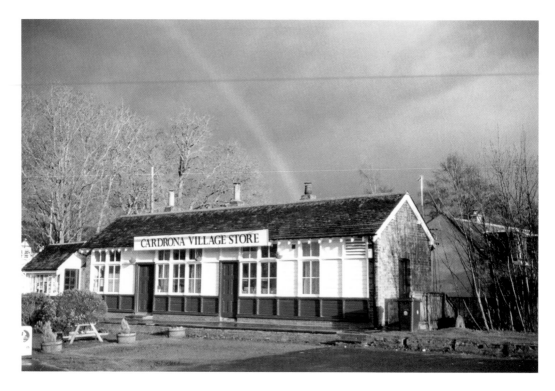

Cardrona Station

Cardrona station was on the North British line from Peebles to Galashiels; the iron railway bridge remains intact, but is unsafe for any traffic and is a handy river crossing for the golfers. A new road bridge was erected parallel to it for access to the village. The wood-panelled booking office was restored and is used as a village shop. The 1937 image was taken at Horsburgh, near Cardrona.

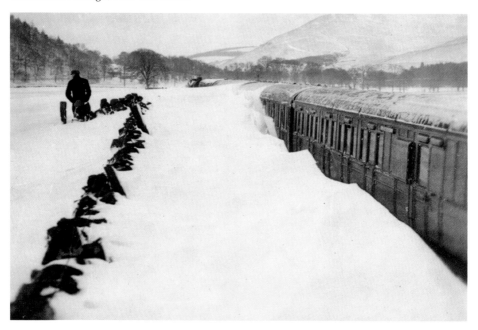

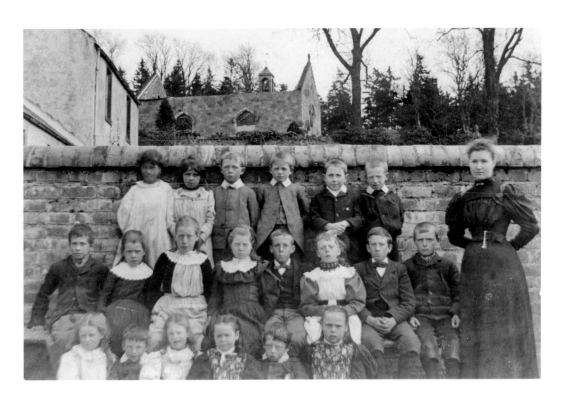

Eddleston School

This Eddleston school photograph was taken around 1900 when there were about eighty pupils attending, some of them boarders. The schoolhouse was behind what is now Horseshoe Inn, accommodation which is presumably of a higher standard than that experienced by the children. In 1993, a new primary school was opened at Burnside. In the background is Eddleston Church, rendered roofless by a fire in 1896, but currently intact.

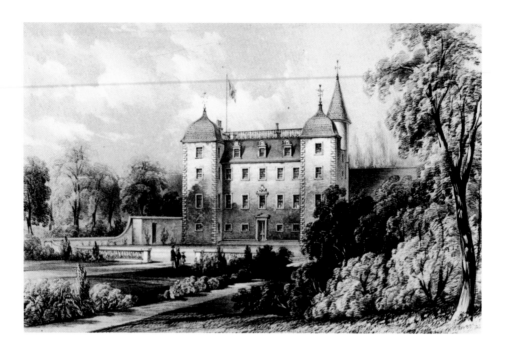

Barony Castle

At the heart of this imposing mansion is a sixteenth-century tower house, considerably enlarged (*c.* 1700) and renovated in 1847, at which time it was in poor condition. The Murrays of Blackbarony, the first owners, passed it to the Murrays of Elibank in 1771. It has been known variously as Darnhall, Black Barony and Barony Castle. In 1930, it opened as a hotel and functions as such today, as well as being the training centre for the Scottish Ambulance Service.

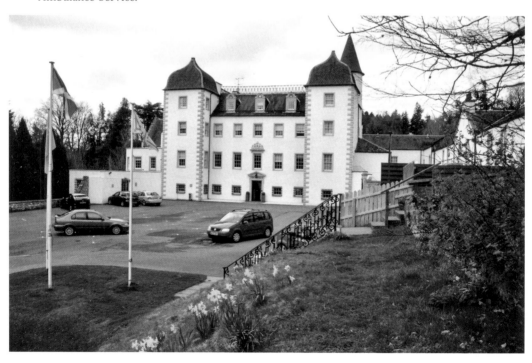

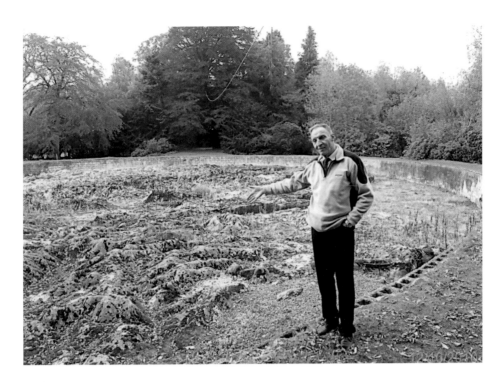

A Map of Scotland

A quirky 'sculpture' lies in the grounds of Barony Castle. Its history goes back to the Second World War, when Polish troops were stationed there. After the war, Jan Tomasik, one of the soldiers, chose to remain to re-open the hotel. Together with his commander, General Maczec, he decided to create a map of Scotland in the grounds to celebrate the hospitality of the Scots and the contribution of the Poles to their defence. Five geography students came from Poland, and completed the map within a few weeks of 1975. Topographically correct, it was surrounded by water that flowed through the river courses. It was neglected after Jan Tomasik died, but plans are currently afoot to restore it. The newspaper photograph below shows two people traversing the Cairngorm Mountains.

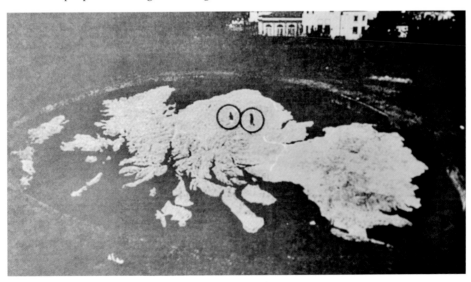

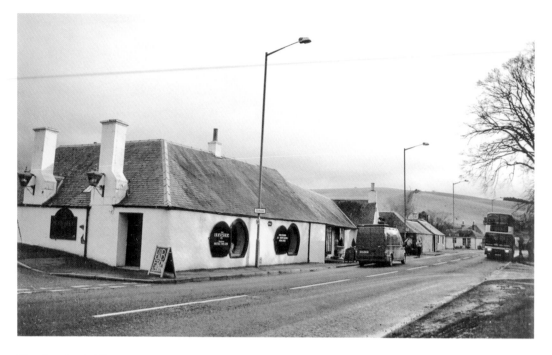

The Smithy, Eddleston

Dating from 1862, this purpose-built smithy advertised itself with windows shaped accordingly. It was on the turnpike road, opened in 1770 between Peebles and Edinburgh, a journey that was thought to take ten hours by horse and carriage. The Lothian bus on the right has none of the charm of the older transport, but it is somewhat faster. The stone building in the background was a corn mill; it has since been replaced by two cottages.

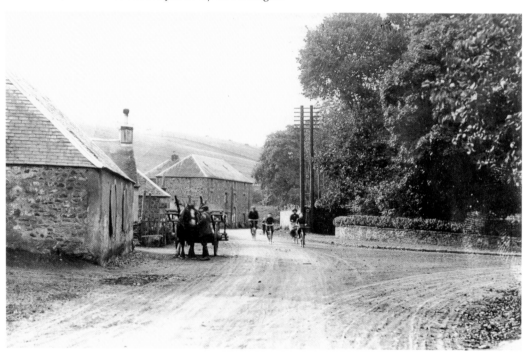

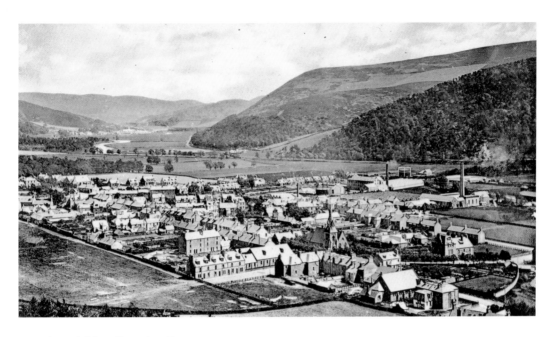

Innerleithen from Lee Pen

Six miles downstream from Peebles, the town of Innerleithen nestles on the banks of the Tweed and its tributary, Leithen Water. The hamlet did not alter much for 600 years until a local man from Traquair – Alexander Brodie – made a fortune in England as a blacksmith, working for a time with Thomas Telford. He came home in 1786 to invest his money in the building of a woollen factory, which was the beginning of an industry that developed and sustained the town for two centuries.

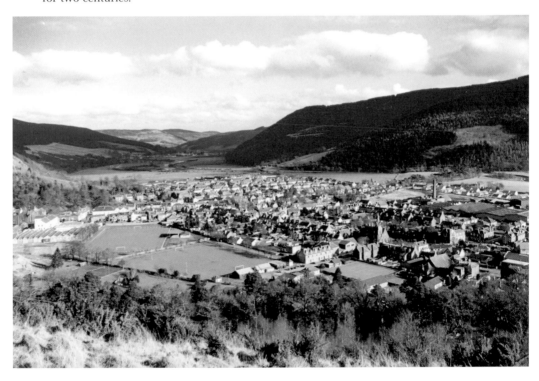

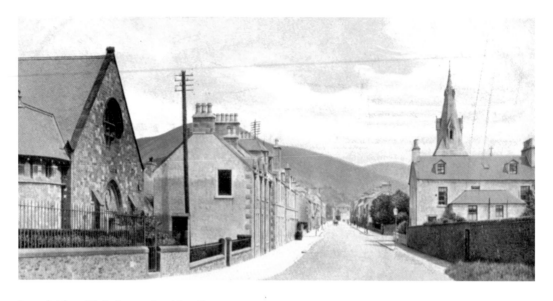

Innerleithen High Street, Looking East
In the late 1890s there were five churches in the town to serve the spiritual needs of about 2,500 souls. The 97-foot-high spire of the Roman Catholic Church of St James can be seen above the house, and is still in use. The Congregational Chapel, on the other hand, was converted into a woollen shop. It is now 'Alpine Bikes', which perhaps illustrates something of Innerleithen's changing fortunes.

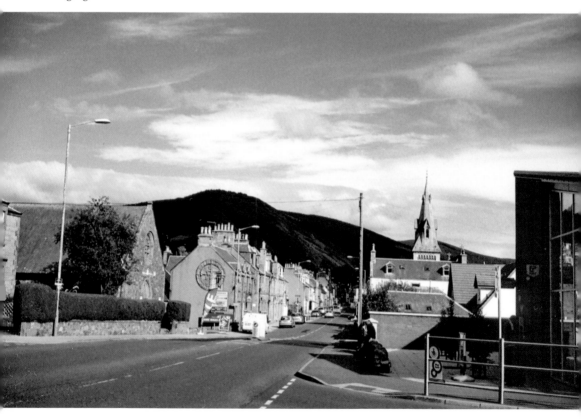

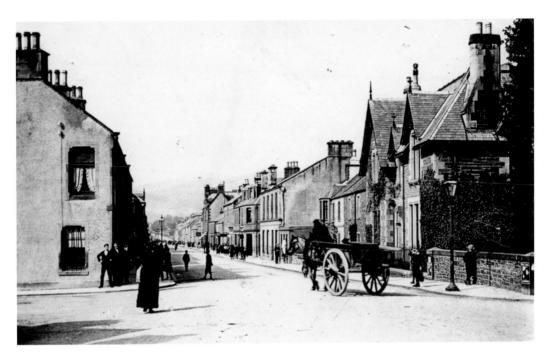

Innerleithen High Street, Looking West

The evolution of Innerleithen into a successful textile manufacturing town began with Brodies Mill. In its heyday, it had seven working mills, two of which were in Walkerburn. The prosperity led to the opening of a branch of the Bank of Scotland in 1863, which relocated to the larger premises on the right of the photograph in 1882. At the time of writing, it is only open part-time.

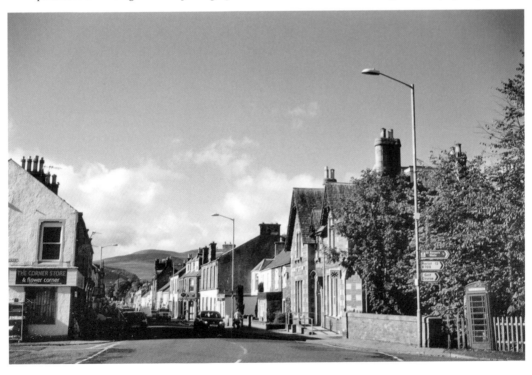

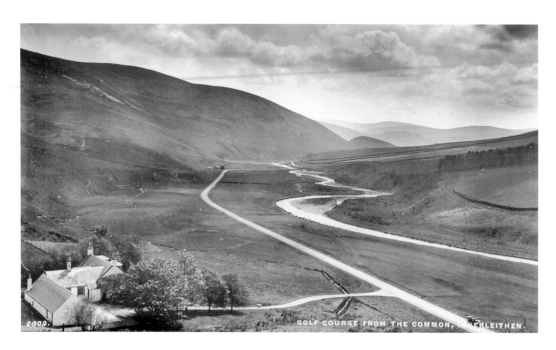

Innerleithen Golf Course

A golf club was started as early as 1886 on farmland belonging to Kirkland, and a clubhouse was built ten years later, being opened by Sir Charles Tennant of The Glen, Traquair. That wooden structure burnt down in 1942 and was replaced by the present one. There have not always been harmonious relations with the farmer, however; once, turnips were purportedly planted on the course and the author remembers seeing sheep grazing on the green. Recently, cattle grids have been installed at either end of the course.

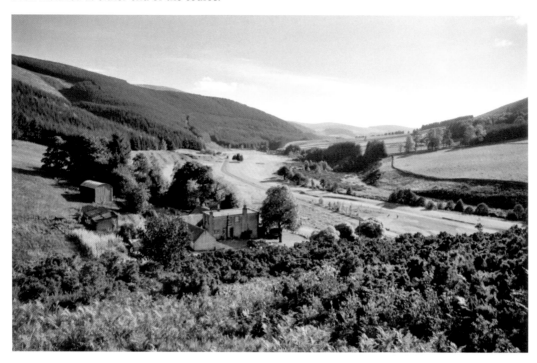

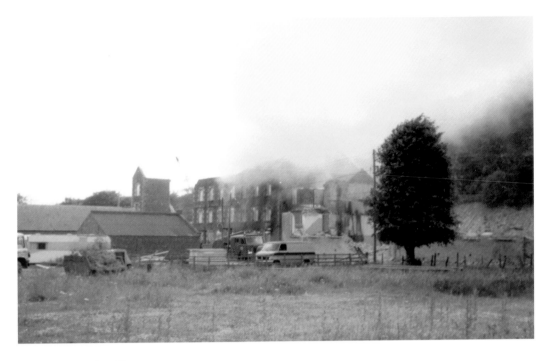

St Ronan's Mill

This mill, one of the smaller enterprises of the mid-nineteenth century, was built in 1846 on the outskirts of the town. It was close to the head of a 1½-mile mill lade, from whose flow machinery was powered. St Ronan's was equipped with up-to-date carding and spinning machines, driven by a huge 26-foot waterwheel. Fire destroyed the factory and a small housing development has since been built on the site.

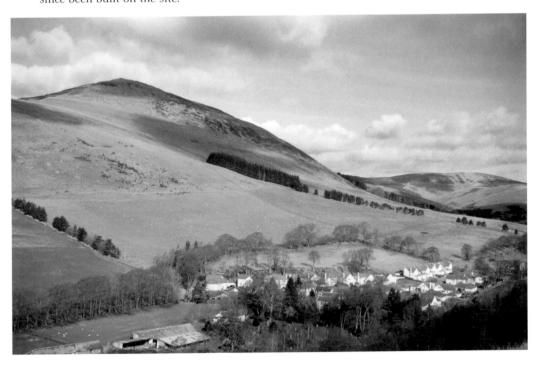

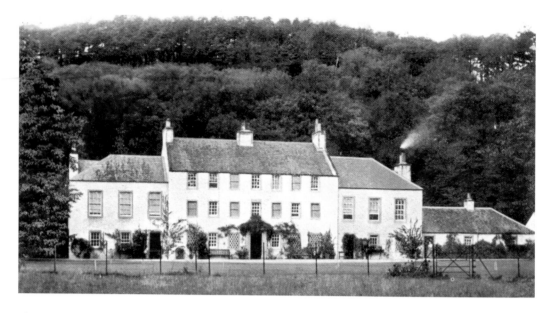

Pirn House

Belonging to the landowner, Thomas Horsburgh, Pirn House was built in 1700 and extended several times, as can be seen from the photograph. After the Second World War, the land was acquired by Innerleithen Town Council and in 1950 it was pulled down in order to build St Ronan's Primary School, which opened seven years later. Children from Traquair are taught here, since their own school closed ten years ago.

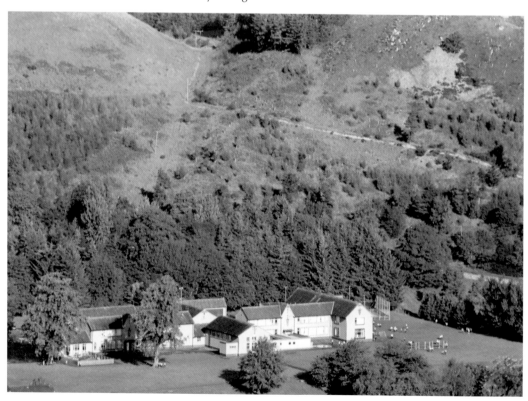

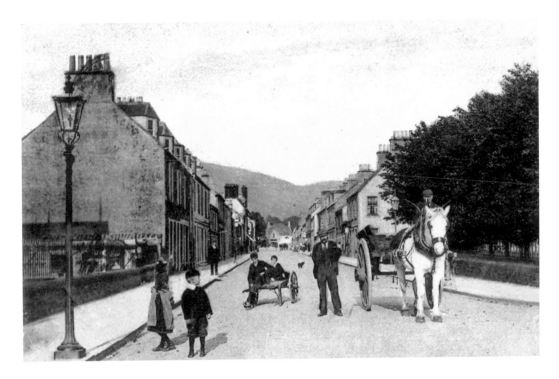

Innerleithen High Street

Much of Innerleithen's High Street was built in the late 1800s when the textile industry was in its prime. Premises of note today are Robert Smail's Printing Works (now owned by the National Trust for Scotland), St Ronan's Hotel (built in 1827) and the shop at No. 92, whose frontage was decorated with ornate tiles by the Buttercup Dairy Company. The woollen industry has declined markedly over recent years, but the town is enjoying a resurgence from the very different business of mountain biking.

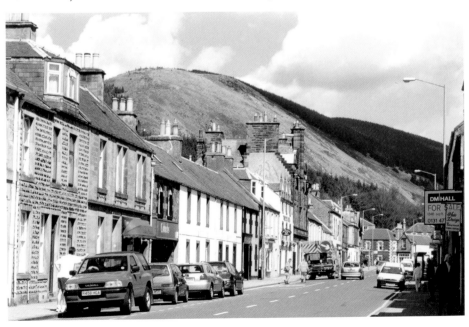

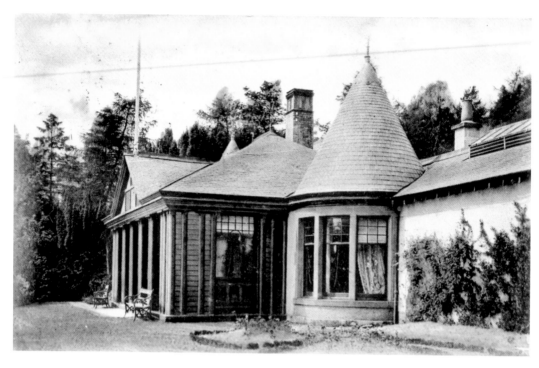

St Ronan's Well

Innerleithen became famous worldwide for the medicinal properties of the spring water flowing out of Lee Pen, especially once Walter Scott had published his 1824 novel *St Ronan's Well*. This boost to the town coincided with the early days of the wool industry and significantly accelerated expansion. A pavilion in which visitors could relax and 'take the waters' was erected on the hillside in 1826, funded by the Earl of Traquair. Today, this attractive structure is an interpretive centre and garden.

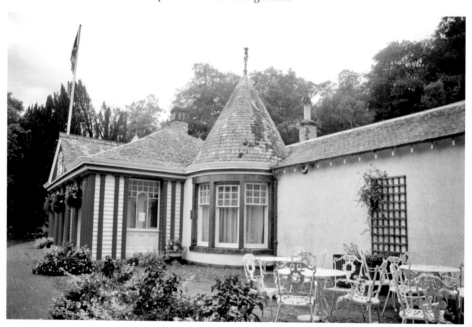

60

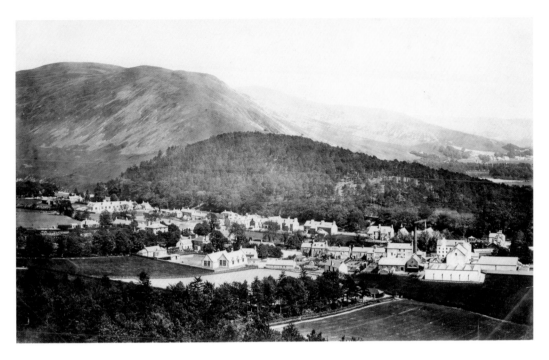

Caerlee Mill

Also known as Brodies Mill, Caerlee Mill, built 1788–90, remains a landmark of the town. The chimneys from the other three mills have been taken down. It operated for 200 years, withstanding wars, market fluctuations and cheap imports, but eventually went into administration in 2010. The future of the massive building is uncertain. Caerlee Mills Ltd still uses a small section as a mill shop.

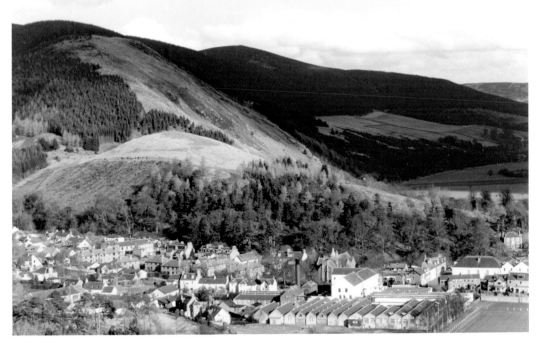

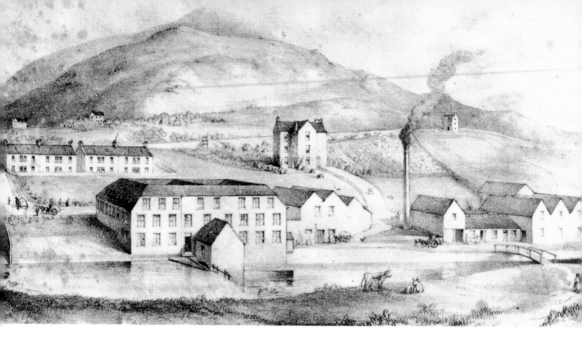

Walkerburn

The metamorphosis of Walkerburn from cluster of cottages and a farm to a thriving, lively village was due to one man – Henry Ballantyne (1802–65). His ancestors had been weavers in Galashiels for 200 years; he and his descendants created a dynasty of woollen manufacturers throughout the Tweed Valley. Despite highs and lows, production at Walkerburn lasted for over 120 years until Tweedvale Mill finally closed down in 1988.

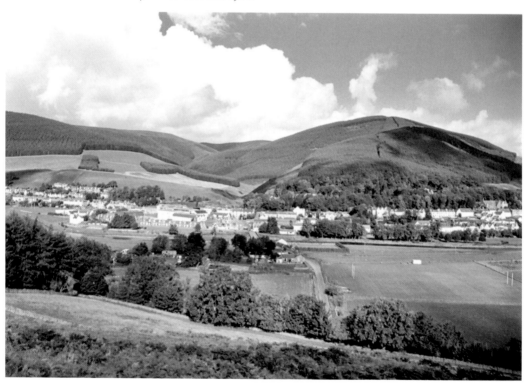

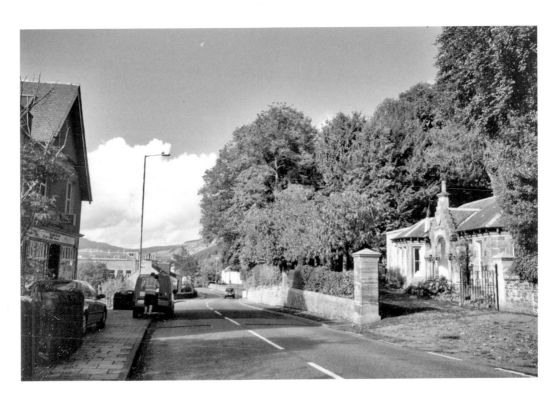

Walkerburn Main Road

The premises on the left have been the local post office since 1910; it was previously located further down the street, where the George Hotel sits. The sloping land on the right, with splendid views across the Tweed Valley, was favoured by the mill owners for building their villas. The Ballantyne family chose the idiosyncratic Gothic style of dwellings by Edinburgh architect Frederick Pilkington, although the lodge of Tweedvale House, shown here, is of more restrained design.

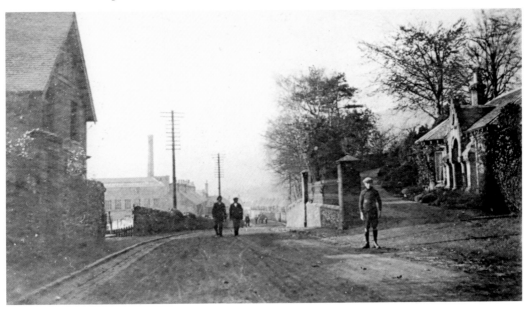

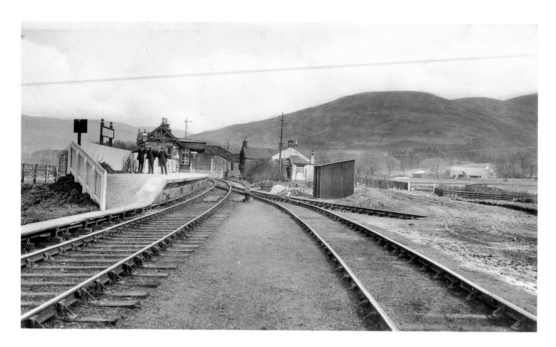

Walkerburn Station

By the time the North British Railway was extended to Galashiels, thereby giving Walkerburn a station, it was 1864, ten years after Tweedvale Mill had opened and five years after the building of Tweedholm Mill. Obviously this conferred enormous benefit to the village, not only for mill workers from neighbouring towns, who had previously walked to work each day, but also because of the better delivery and dispatch of materials and goods.

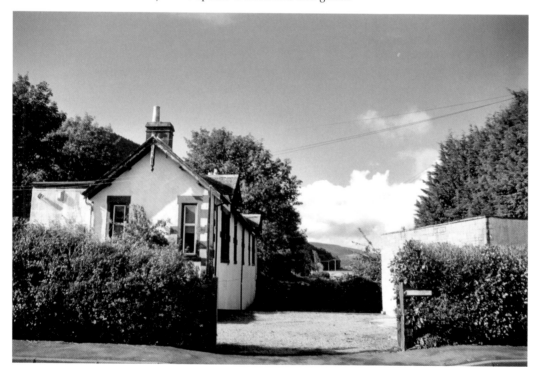

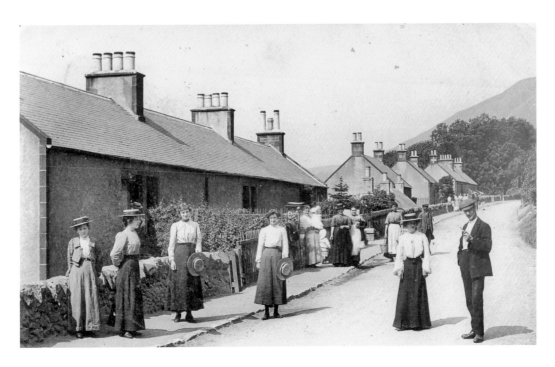

Mill Cottages, Walkerburn

In 1891, Walkerburn was prospering and still growing; the population was 1,288. The village had a school with 250 pupils, a post office, a church, and a variety of shops. Houses continued to be built by the mill owners, as and when needed, and the community spread out from the epicentre of the mills in a haphazard fashion. Oddly, this road is named Pink Bank.

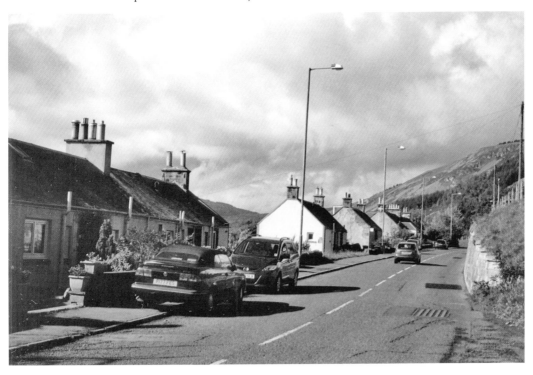

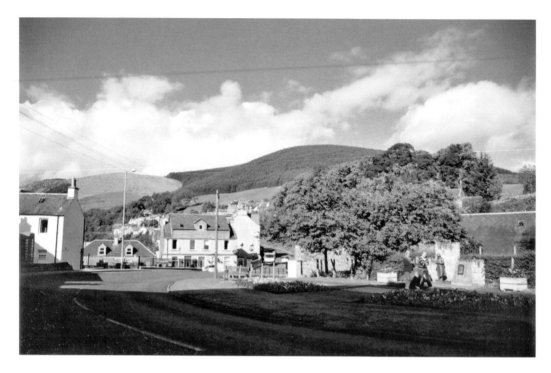

Walkerburn Village

Some of the first houses to be built for mill workers are on the left of the road; they were cramped, with outside toilets, but despite this some residents also took in lodgers. Caberston Farm sits behind the high wall in the heart of the village and existed before the mills were built. At the time of writing, a coffee shop has been opened in a converted farm building, outside which is a Victorian 'pissoir' (although modern facilities can be found in the café).

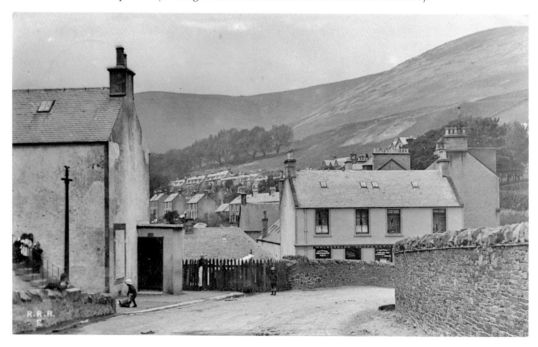

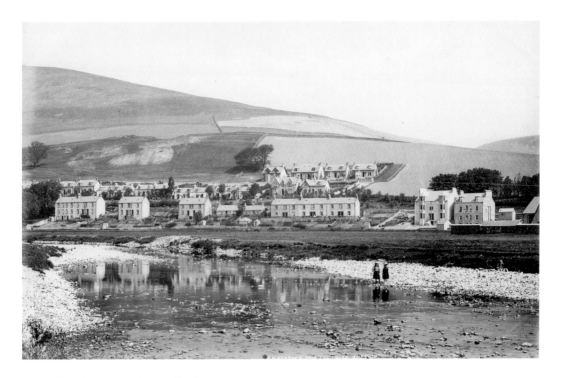

The River Tweed at Walkerburn

Parallel to the River Tweed at Walkerburn was a mile-long mill lade, the flow from whose water was used to turn the enormous breast wheels that powered the mill machinery for sixty years. School archives show that it was not uncommon for children to drown in the fast-flowing channel. It was infilled in 1981 using earth from the railway embankment, both features having become redundant.

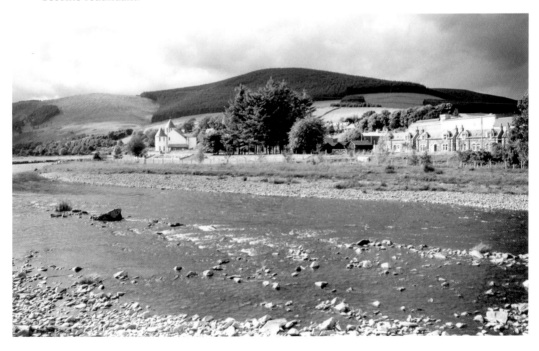

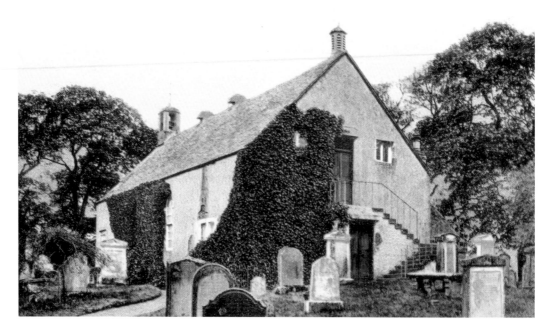

Traquair Church

The present church dates back to 1778, although an ecclesiastical site known as Kirkbride is recorded here as early as the twelfth century. It served as the place of worship for the Catholic Stuarts of Traquair House, who have a burial aisle within. The parish was extended to incorporate Kailzie parish, whose old church is at Kirkburn, in 1674. For the past thirty years the church has been united with those in Walkerburn and Innerleithen.

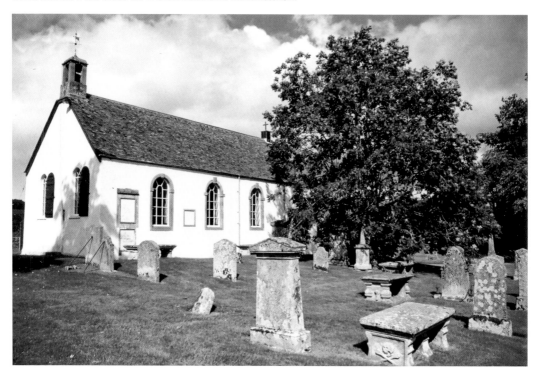

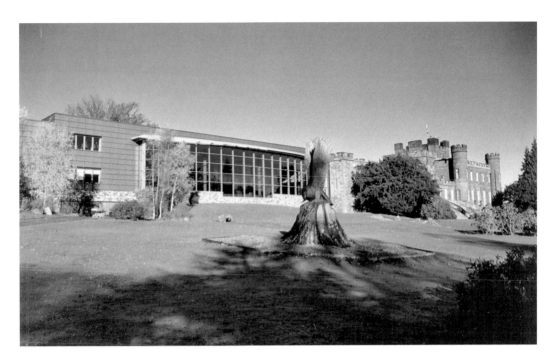

Stobo Castle

In 1805 James Montgomery had Stobo Castle built on the land his father had purchased in 1767 – an elevated location overlooking the Tweed valley, 8 miles upstream from Peebles. His son, Hylton Philipson, created a Japanese water garden in 1905, which frequently opens to the public. In 1975, Champneys – and shortly afterwards, the Winyard family – converted Stobo Castle into a health spa. Over the past twenty years it has been extended and modernised and it now includes a glass-roofed spa area and large swimming pool.

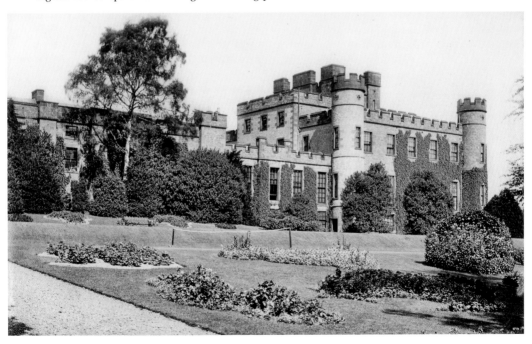

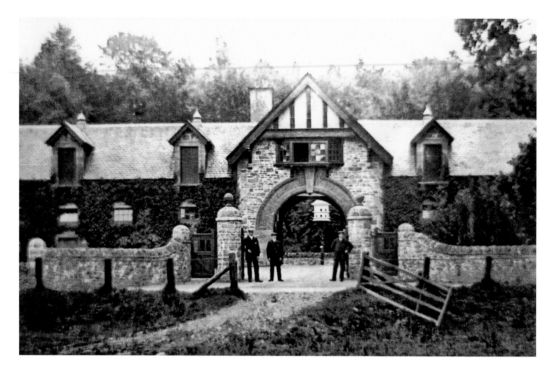

The Stables, Dawyck House

The name of Dawyck is probably known best these days for its arboretum, a satellite garden of Royal Botanic Gardens, Edinburgh, gifted to Scotland by Colonel F. R. S. Balfour in 1979. The present Dawyck House was built in 1832–37, but the stables, beside the road at Bells Pool, date from *c.* 1860. In 1978 the buildings were listed and in 2005 they were converted into an unusual dwelling.

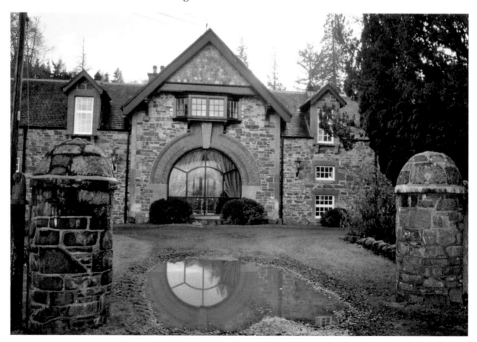

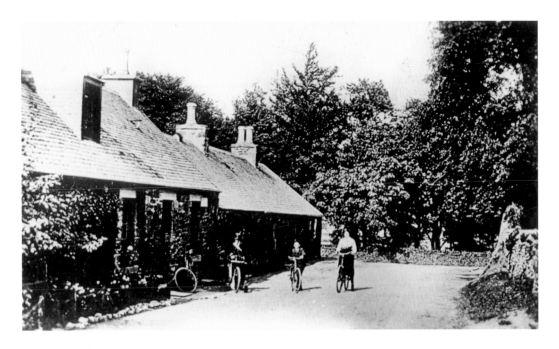

Drumelzier Cottages

The village comprised twenty-six houses with ninety residents at the end of the eighteenth century. They would have been self-reliant, growing grain and vegetables, keeping a few farm animals, and no doubt procuring the odd fish from the Tweed. By 1893, although the number of villagers had dropped, there was a smiddy, a shop and a school. A post office opened in 1908. Public telephone arrived in the 1930s; calls could be made from inside the shop until the kiosk was put beside the road. That structure remains, but it is no longer connected.

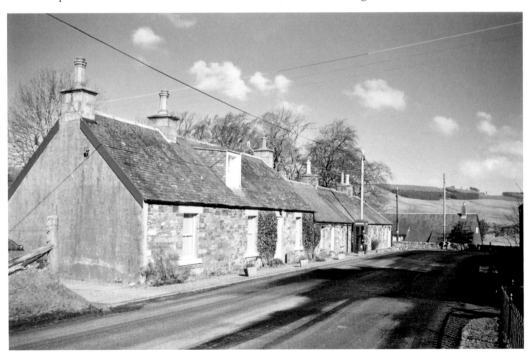

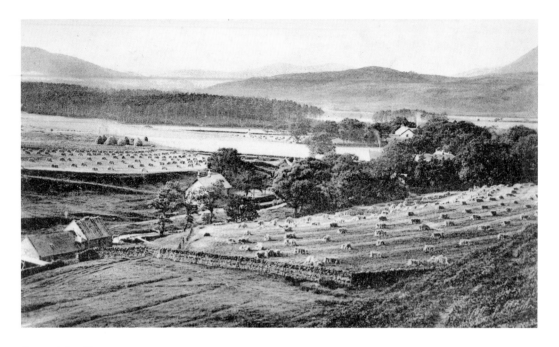

Drumelzier Glen

This parish is synonymous with the Tweedie family. Despite the appealing name, they were violent, quarrelsome people, filling the valley with fear for about 300 years. In modern parlance, they were truly 'the neighbours from hell'. Their strongholds were Tinnis Castle, strategically placed on a rocky knoll above the village, and Drumelzier Castle, a mile away on a bend in the river. How different it is today; the tranquillity and beauty of Drumelzier Glen is, in the author's opinion, unsurpassed.

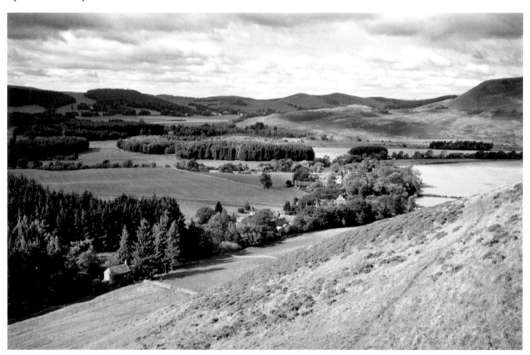

Skirling Green

The village green at the heart of Skirling is encircled by pretty cottages, a farmhouse and the distinctive Arts and Crafts-style Skirling House. On the opposite side of the road, the church is perched on a hillock, at the foot of which is the old schoolhouse. The last shop in the village was located within the porched house on the left; it ceased trading in the mid-1980s.

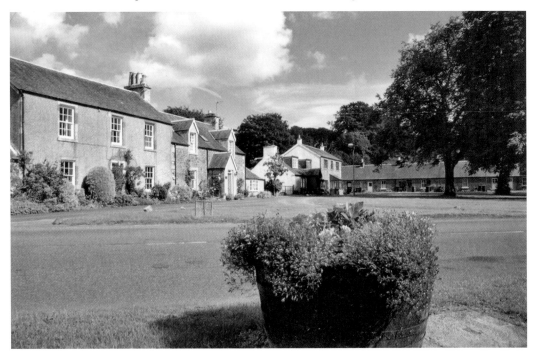

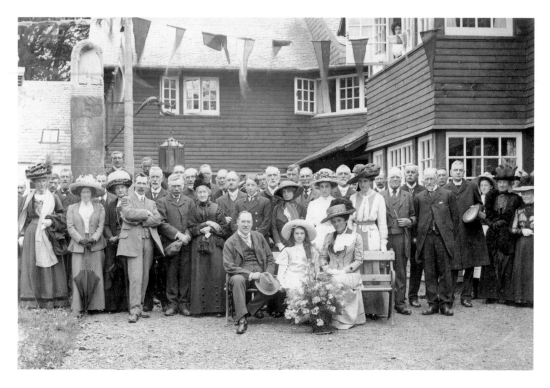

Skirling House

Farm buildings at the lower edge of the green were creatively converted into Skirling House in 1908–12 by architect Ramsay Traquair, under the instruction of Lord Carmichael of Skirling. The latter was fascinated by the wrought-iron artwork of Thomas Hadden of Edinburgh, whose quirky figures and animals can be found throughout the house and garden. Skirling House is now used as an exclusive bed and breakfast.

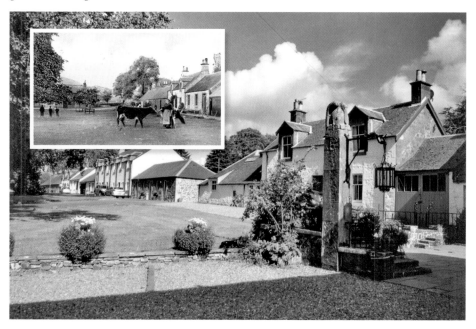

Skirling War Memorial

Looking north from the war memorial is a group of houses called Howes Brae, named after the animal painter James Howe (1780–1836), the son of a Skirling minister. His most famous work was *The June Horse Fair in Skirling*, which was based on one of the quarterly events held where the houses now stand. These animal sales were moved to Biggar in 1864.

Skirling from the Kirkyard

The history of Skirling Church is sketchy, although reference to it was made in 1275. The present building dates back to 1720 and was altered in 1891. It is still in use and is one of the four parishes of Upper Tweeddale, along with Broughton, Tweedsmuir and Stobo. The circular graveyard is enclosed by a ha-ha and the Ministers Gate is a Thomas Hadden wrought-iron design. The 1843 Free Church, which has been converted into a dwelling, is visible in the background.

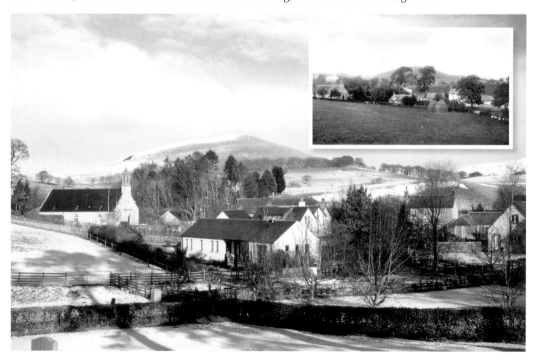

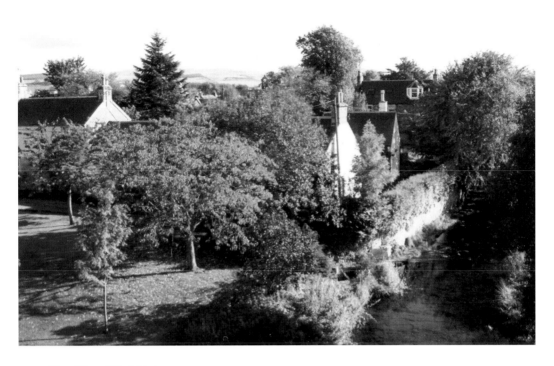

Glen View, West Linton

West Linton, through which Lyne Water flows, sits below the slopes of the Pentland Hills at the western edge of Peeblesshire. The lower of the two village greens was where sheep sales were held during seventeenth and eighteenth centuries. The breed was known as Linton and is thought to be what is now called Blackface. The sheep's ancestors came from the flocks of Ettrick Forest. A spring called Rumbling Tam emerges close to the upper green and its water was harnessed for village use before improvements brought piped water in late 1800s.

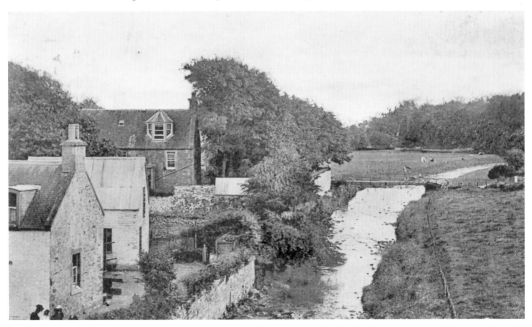

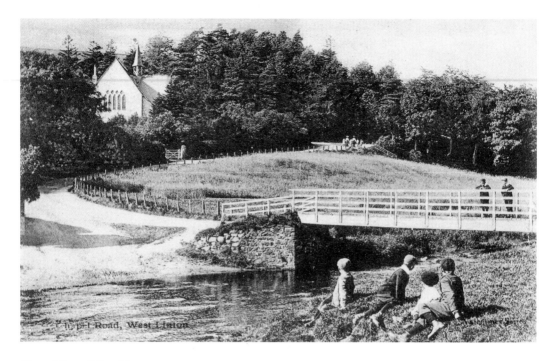

Chapel Brae, West Linton

Three churches served the community; one of these, the Episcopalian Church of St Mungo, can be seen at the top of Chapel Brae. The Parish Church of St Andrew has recently celebrated its 850th anniversary, although the present building dates from 1781 and the spire was added in 1871. The former Trinity United Presbyterian Church has been converted into a house. All three ran their own schools until the passing of the Scottish Education Act of 1872.

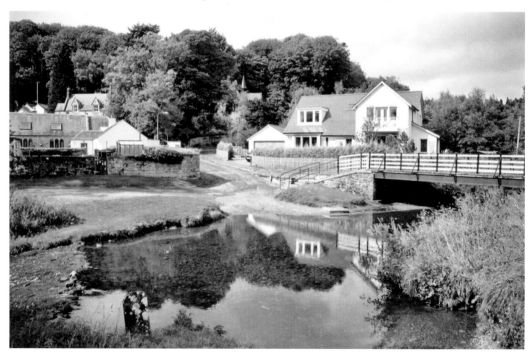

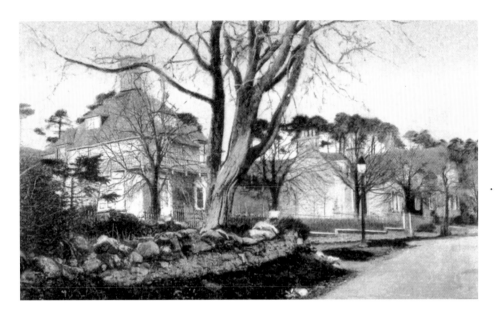

Villas, West Linton

A railway line was opened in 1864 from Edinburgh to Dolphinton, stopping at West Linton. This started to bring visitors from the city, who required accommodation. Thus began an expansion of the village, and villas such as these were built in both Victorian and Edwardian times as summer residences. Passenger trains ceased in 1933, superseded by motor vehicles and the establishment of the A702 trunk road, which also facilitated West Linton's continued growth in the twentieth century as a commuter village.

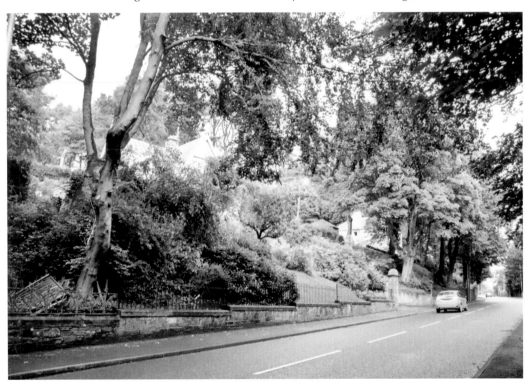

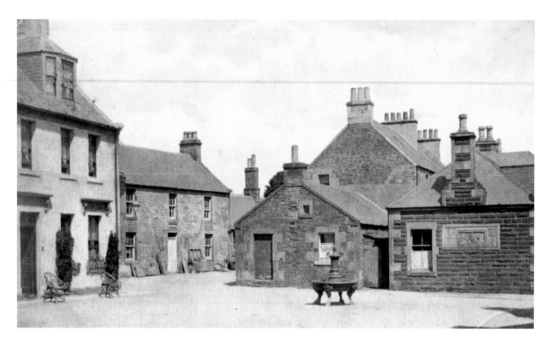

Raemartin Square, West Linton

There is a history of stone carving in West Linton, partly due to the proximity of good raw material at Deepsykehead Quarry. The best-known craftsman was James Gifford, whose 1660 carved panel is integrated into the gable end of a cottage opposite Raemartin Square. The cast-iron horse trough, installed to commemorate Queen Victoria's Diamond Jubilee in 1897, was relocated to Church Corner. The Raemartin Hotel, built in 1789, served travellers on the journey between Edinburgh and Moffat.

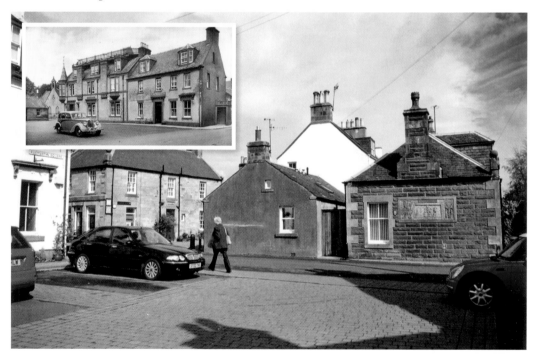

Main Street, West Linton

The charm of West Linton comes from the higgledy-piggledy layout of the older buildings, which creates unexpected closes, squares and mews. The asymmetry gives the village a unique character. When the post office opened, the description 'West' was added to the name of Linton to distinguish it from East Linton, a village some thirty miles away.

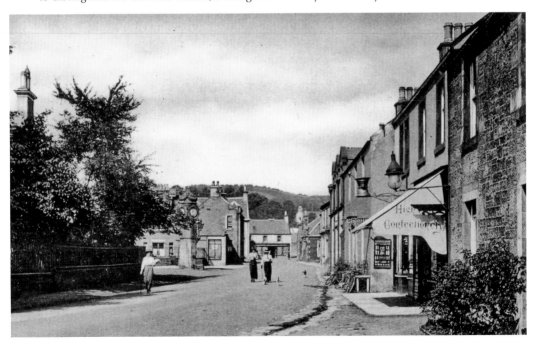

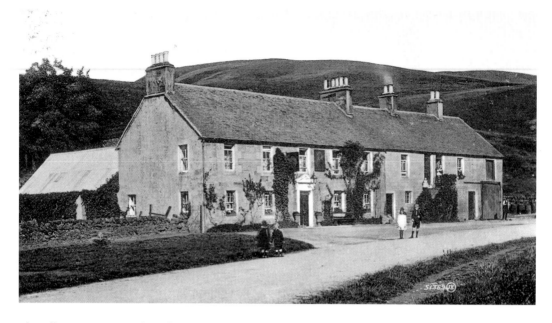

The Allan Ramsay Hotel, Carlops

In 1784, Robert Brown, Laird of Newhall, built a row of single-storey cottages along the foot of Carlops Hill during the creation of a cotton-weaving community. That industry only lasted about a hundred years, but the village of Carlops had been established. The inn, dated 1792, is thought to have been initially used as a wool store, but was converted into a hostelry in the mid-1900s and still functions as the Allan Ramsay Hotel today. The man after whom this was named was a local poet best known for his pastoral play *The Gentle Shepherd*, the setting of which was Newhall.

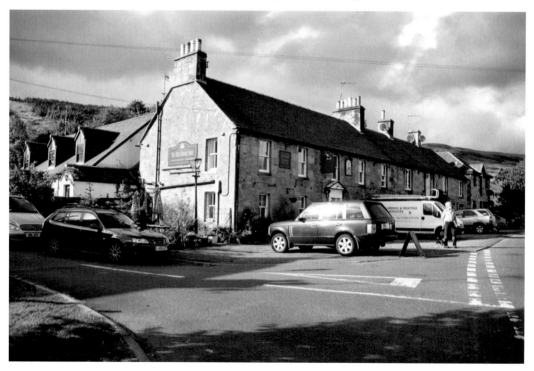

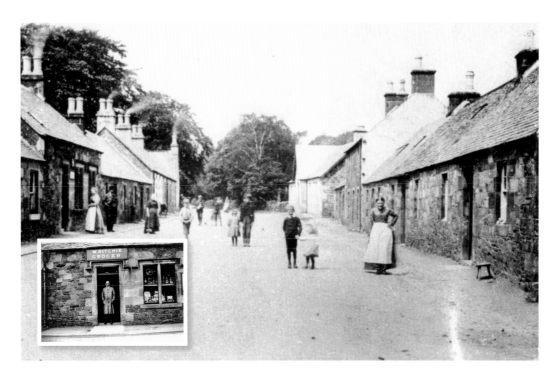

Main Street, Broughton

Broughton is a thriving village with a strong community spirit, supporting a primary school (currently teaching about a hundred pupils), garage, post office, café/bistro and village shop. The premises of the latter were used as a school in the nineteenth century and the cottage next door housed the teacher; the connecting door still exists. After the Second World War, the shop was run by Mr W. Ritchie. He had a small sales area in the front, with a larger store behind, in which were supplies of dry goods such as oats and flour that were sold from open sacks. However, this room was also home for his collection of canaries.

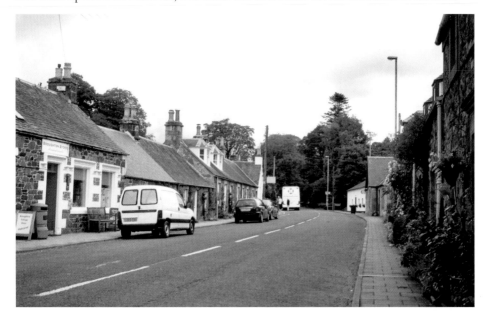

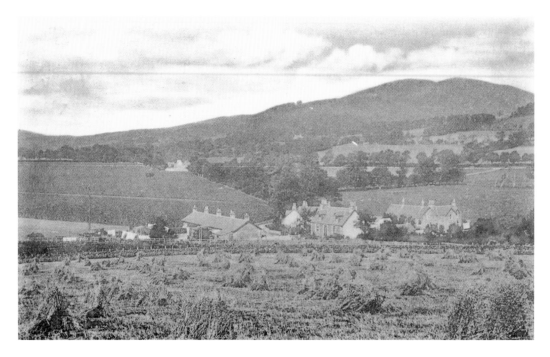

Broughton Heights

Broughton straddles the valley between the hills of the upper Tweed Valley to the south and the spine of Broughton Heights to the north. Broughton Place Glen lies below the nearest hill in the photographs and it was here that the lairds of the Barony of Broughton lived in Broughton House. In 1634 it was purchased by the Murrays of Stanhope; John Murray was secretary to Prince Charles Edward Stuart during the Jacobite Rebellion.

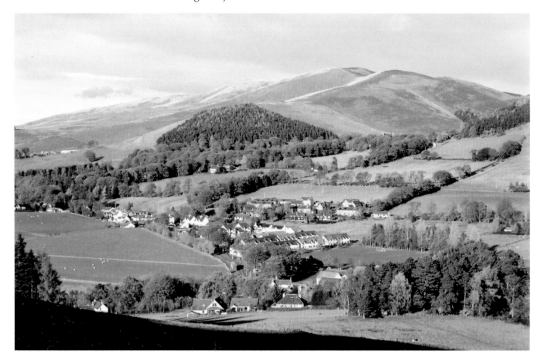

Broughton Place

James Dickson MP was the next owner of Broughton House, and he was responsible for rebuilding and improving much of the village itself. Fire destroyed the mansion in 1773 and it was 1937 before there was a replacement. Professor Thomas Elliot and his wife employed Sir Basil Spence to design a new dwelling in the style of a seventeenth-century Scottish tower house. They called it Broughton Place.

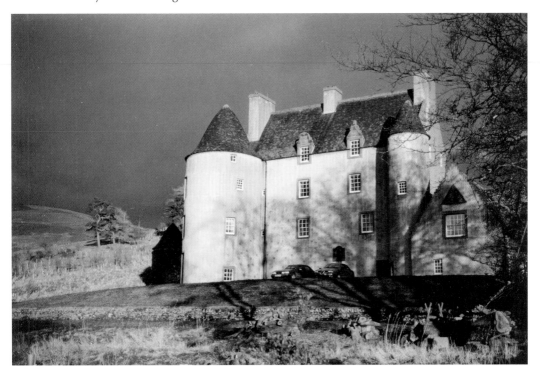

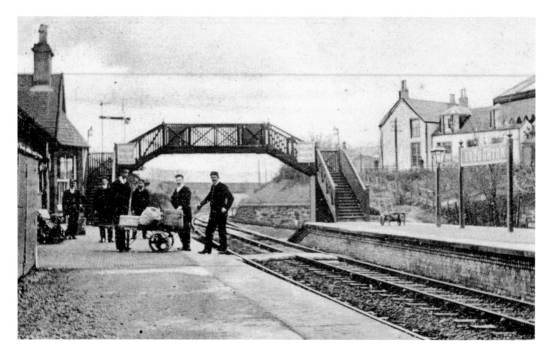

Broughton Station

The opening of the railway line from Symington in 1860, and its extension to Peebles three years later, was to transform life for many villagers. In *Life and Times in the Upper Tweed Valley*, Andrew Lorimer recalls cycling 8 miles from Tweedsmuir daily to catch a train to school in Peebles – a familiar story for children from far-flung communities. Very little remains of the station; it is now used as a works yard, and the old rail tracks make for scenic walks.

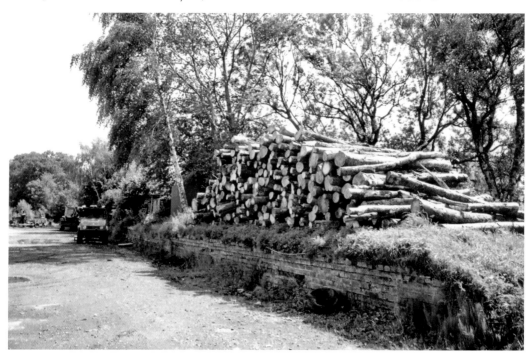

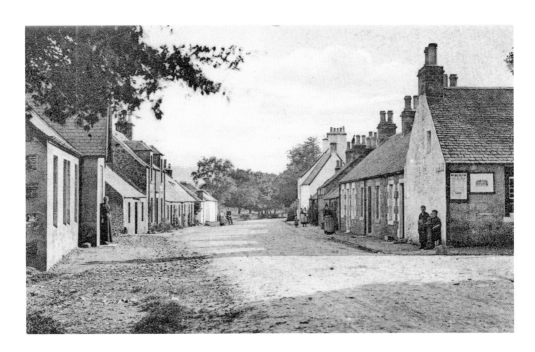

Main Street, Broughton, Looking South

The village hall on the left was built in 1885 by the Broughton Estate and the white cottage opposite, used as a police station for a while, is now Laurelbank Tearoom and Bistro. It was previously called 'The 39 Steps', a reference to John Buchan, who is inextricably linked with Broughton. The Masterton family, related by marriage to the author, still farm in the vicinity and his granddaughter resides in Broughton Green, home of both the Buchan and Masterton families since 1921. The John Buchan Museum is in the old Free Church building.

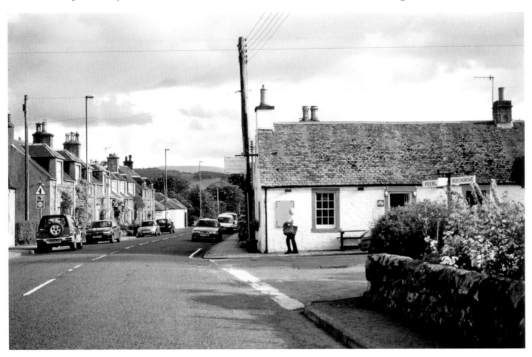

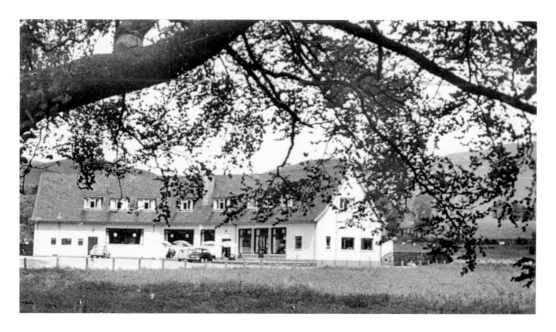

Greenmantle Hotel

In the mid-1960s the owners of the Elphinstone Hotel in Biggar, Mr and Mrs Barrie, built the Greenmantle Hotel in the style of an American motel. It was thought at that time that the A701 road through the village would be upgraded and become the main route south from Edinburgh, which (thankfully) did not happen. Nonetheless, business was brisk at that time, due to the influx of labourers employed in the building of Fruid Reservoir and its dam. The hotel eventually closed and was demolished to make way for a small group of detached houses.

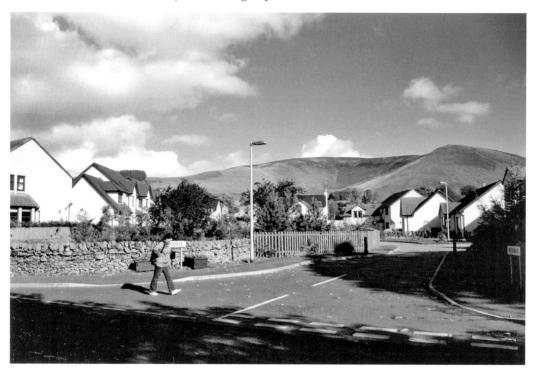

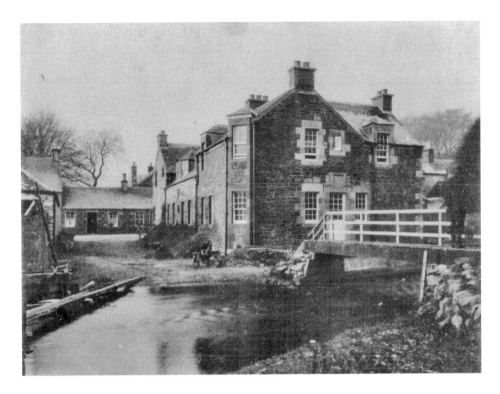

Dreva Road, Broughton

Broughton Burn flows south from Broughton Heights, past Cloverhill and parallel to the main road through the village until its confluence with Biggar Water near the school. Dreva Road branches off at right angles in the centre of Broughton and, until 1923, the burn was crossed by a ford. The houses beyond the footbridge had been rebuilt a few years earlier, the nearest one having been the smiddy.

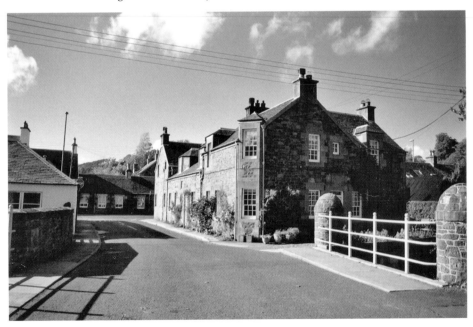

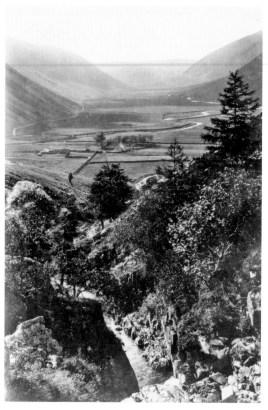

Talla Water

In 1894, as Talla Water cascaded down the Linns and through the glen to Tweedsmuir, a decision was made in Edinburgh that would change this natural landscape. The high rainfall of the area was to be harnessed by a reservoir that would help to satisfy the growing needs of the city. A railway track was laid between Broughton and Talla, 34 miles of aqueduct were constructed, and thousands of tons of squared stones for the dam face were transported from Edinburgh quarries. The labour force temporarily swelled the population of the upper Tweed Valley significantly, but today Talla Water is a quiet and remote place once again.

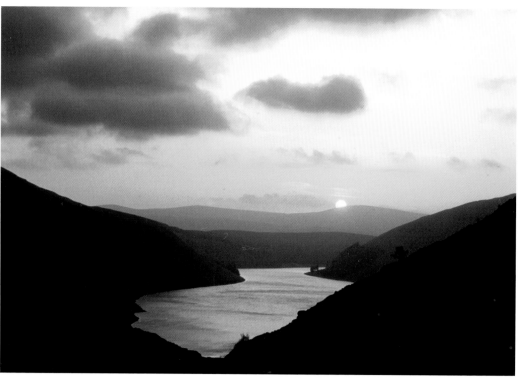

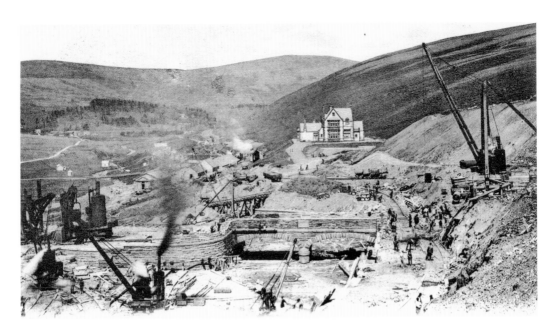

Construction of Talla Reservoir

28 September 1905 was unique in the history of Tweedsmuir. Two rail carriages, filled with dignitaries, were pulled from Broughton station to Talla for the official opening of the reservoir; they were met by throngs of spectators, bunting and flags. No expense was spared by the trustees in constructing the impressive Victoria Lodge, where site board meetings were held. Currently it is inhabited and offers luxury accommodation.

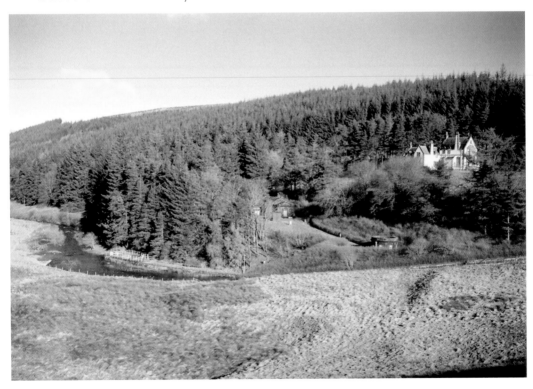

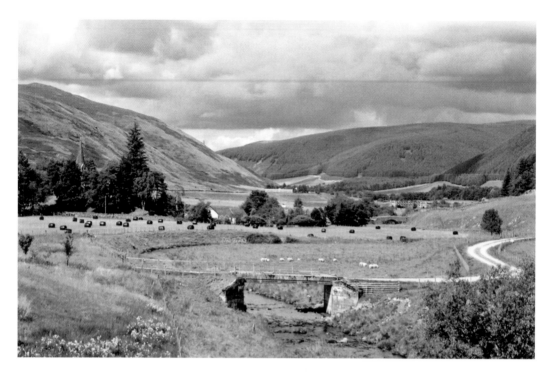

Curling Pond, Tweedsmuir

In the finger of land between Talla Water and Tweed, a waterlogged area was utilised as a curling pond during Victorian times. Tweedsmuir Curling Club existed for many years and a tin shed 'clubhouse' known as the Curlin' Hoose, heated by a simple stove, was erected. The spire of Tweedsmuir Kirk can be seen in the distance; it was built in 1875, replacing the earlier one of 1648.

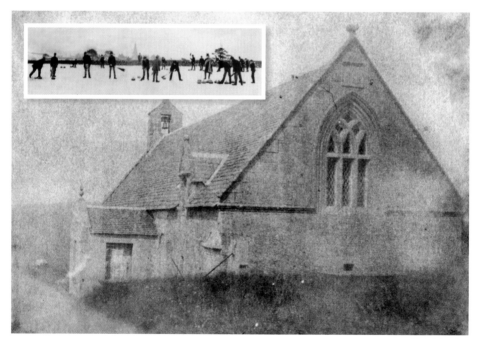

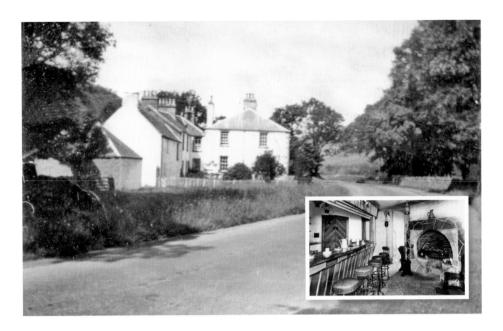

The Crook Inn, Tweedsmuir

The sight of a neglected Crook Inn with its overgrown gardens is a sad one. It had been a hostelry to travellers and locals for over 400 years and was one of the oldest licensed premises in Scotland, but it is now closed. Architecturally, it is an unusual mixture of styles; at the heart is the flagstoned Willie Wastle's Bar, encased by a stone Victorian block and finished off with 1930s curved windows at the entrance. The Art Deco cloakrooms were considered novel features by the patrons.

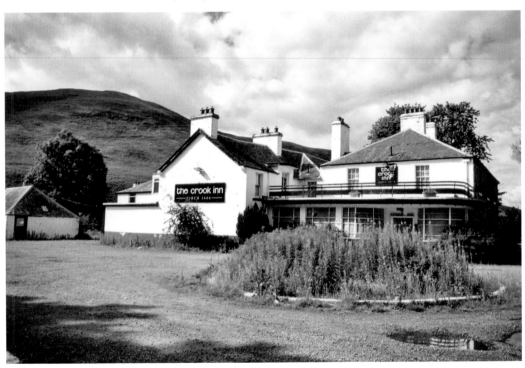

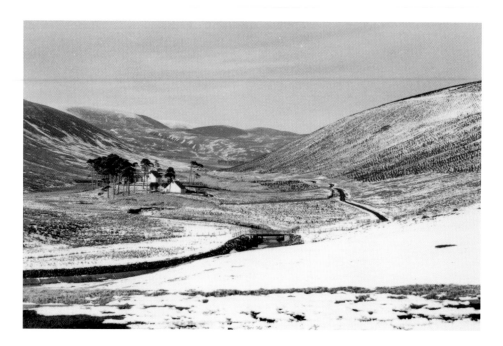

Fruid Reservoir

In the 1960s, the remote Fruid Glen was chosen as the location for a reservoir that would augment Talla Water as a source of drinking water for Edinburgh's increasing requirements. These uplands are low in nutrients and pollutants and receive high rainfall. For the same reasons, the area is favoured by the Forestry Commission, who, at around the same time, forested large swathes of the hillslopes. At the time of writing, the now-mature trees are being harvested.

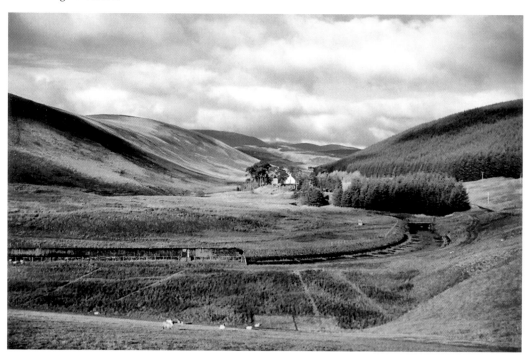

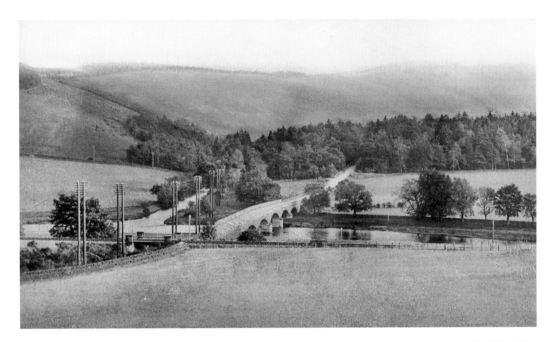

Manor Water

The Earl of March was responsible for funding the simple, single-arched bridge over Manor Water in 1702. Recently, cracks have appeared and only cycles, horses and pedestrians are able to cross it. A short distance downstream, Manor Water flows into the River Tweed near the main Manor Bridge of 1881–83. At the northern end of this, the Caledonian railway ran parallel to the river; this train journey to Broughton, along the upper Tweed Valley, must have been a picturesque ride.

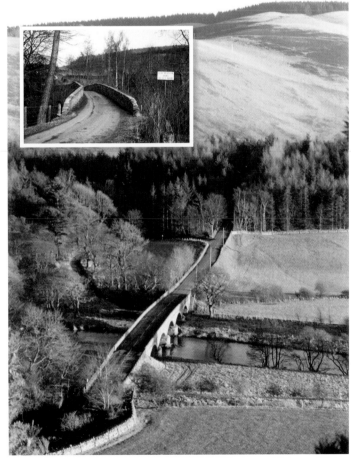

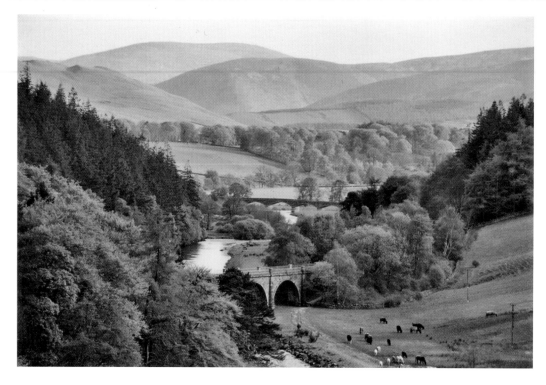

The River Tweed, Neidpath
The view upstream from Neidpath Castle epitomises the character and beauty of Peeblesshire. The viaduct carried Caledonian trains on the branch line from Symington Junction to Peebles, the terminus.

About the Author

Liz Hanson was born and brought up in Kidderminster, and has lived in the Scottish Borders for thirty-five years. Photography has been her hobby since, as a teenager, her parents bought her a Brownie 127 box camera. Her career has been in microbiology, but after redundancy in 1990, she started her own business producing photographic cards.